IMAGES
of America

GENEVA
ILLINOIS

DATE DUE

IMAGES
of America

GENEVA

ILLINOIS

Jo Fredell Higgins

ARCADIA

Published by Arcadia Publishing
Charleston SC, Chicago IL, Portsmouth NH, San Francisco CA

Printed in the United States of America

Library of Congress Catalog Card Number: 2002107392

For all general information contact Arcadia Publishing at:
Telephone 843-853-2070
Fax 843-853-0044
E-mail sales@arcadiapublishing.com
For customer service and orders:
Toll-Free 1-888-313-2665

Visit us on the Internet at www.arcadiapublishing.com

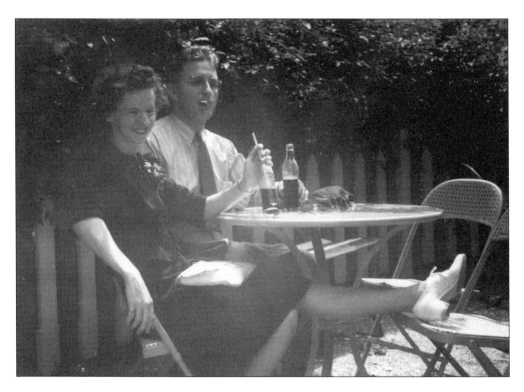

To My Mother, Mary Scherer Fredell, and Daddy, Raymond E. Fredell
With Everlasting Love.

CONTENTS

ACKNOWLEDGMENTS

The city of Geneva—harmonious, serene, neighborly, optimistic, remarkable—is presented to you, dear reader. I am reminded of Irving Berlin's hit of 1929: "Blue skies smiling at me. Nothing but blue skies do I see." This describes the city of Geneva! Hospitality is a way of life. Each time I met with a new resident, I left their home pleased, enchanted, full of the kindness they had bestowed on me—a writer and photographer whom they had just met!

For comfort and encouragement, for sharing and contributing, for time together in sweet reminiscence, I give thanks. For time lingering over teacups at a table graced with a lace doily and a plate of homemade oatmeal cookies, I thank those who helped bring this book to life. These distinguished names include Lawrence A. Hagemann, Mayor Kevin Burns, Dr. Christine J. Sobek, Margaret Hutton, Suzanne Higgins, Sean Higgins, Ray Fredell, Pat Hagemann, Merritt A. King, John Jaros and the Aurora Historical Society, Emmie Lou Boston, Eleanor and Art Fisher, Hilmer Youngberg, Nancy Bell, Lynette Hoover DeYoung, Dr. Steve Parker, Daniel Mitchell, Mark and Debbie Lewis, Nancy Sexton, Sue Anderson, Donna Peddy, Bruno Bartoszek, Dick and Wendy Wessels, Esther Wessels, Sherri Weitl, Michelle Donahoe, Bernice Kibble, Mary Sanchez, Janet Dellaria, George Sawyn, Barb Norbie, Brenda Schory, Earl and Pat Hanson, Tom and Marie Peck, Marion Peck, Judy Anderson, Carol Leonard, Lorraine Erdmenger, Nina Attlers Heymann, Joan Obermayer, Gregg Nelson, Richard Miller, Margaret Martin, Helen Moore, Pietro Verone, Marty and Dan Grunwald, Darlene Larson, Todd Koenitz, Geneva History Center, Keith Coryell, Rama Canney, Randolph Riotto, Joanne Maros, Marie L. Berg, Jackie Shanahan, Frank Burgess, American Legion Post 75, Carolyn Hudspeth, Alice Hawkins, and my editor, Jessica Belle Smith.

CITY OF GENEVA
Office of the Mayor
22 South First Street
Geneva, Illinois 60134

Dear Reader,

Welcome to a fascinating photo history book on the beautiful City of Geneva. From the earliest beginnings to the present day, genteel country elegance has become the hallmark of the Fox River Valley town.

Geneva maintains the old world charm and ambience that characterizes a city rich in history. Blended together with appealing shops, a diversity of restaurants, bike paths, family festivals and seasonal events, Geneva continues to be a pleasant place to live, play, work, and raise a family.

I hope you enjoy this book on the City of Geneva. The vintage photographs counterpoint the present ones and show how Geneva became the dynamic and distinctive city that it is today.

Sincerely,

Kevin R. Burns

Introduction

Since the earliest days of its founding, society in Geneva, Illinois, has been agreeable and pleasant. A Rand McNally travel booklet titled "Summer Resorts of the Northwest" from 1879, told the reader that Geneva "is a quiet, restful place, where there is a perpetual air of a New England Sunday afternoon. There is a natural atmosphere of *dolce farniente* and the shaded summer streets are cool and quiet. The scene on the arrival of the evening train is quite like that at many Eastern resorts."

A variety of ethnic groups settled Geneva. From Sweden, Italy, Germany, Scotland, Yugoslavia, and Romania the settlers came to reside on the rich prairie land of Kane County, Illinois. Since its founding, Geneva has been a desirable place of residence on the Fox River. The attractive location, pleasant natural surroundings, and healthy small-town American lifestyle have contributed to Geneva's inevitable and anticipated destiny as a beautiful and remarkable country town.

The picturesque landscapes of Geneva first attracted settlers in the mid-1800s. Frederick Bird, his wife, Louisa, their three children, and Louisa's sister, Harriet Warren, rode in a lumber wagon through the woods to the river. Bird's wagon suddenly plunged into the water, and the travelers were so startled that 54 years later, Harriet recalled, "Our hearts were in our throats until we were safely across. The first object to meet our view was the large wigwam of the Indian Chief Wabaunse which was remarkable for its neatness. We came up as far as where Geneva now stands on the west bank of the river and were charmed with the lovely landscape all the way."

This story of Geneva, Illinois, explores the community from the 1820s to the present day. Vintage photographs define every page with captions that explain and illustrate the town's legacy. Photography is a nostalgic phenomenon. The moments that the photographer captures are ever the past, ever receding. This wholesome community provides both residents and visitors with the vintage flavors of an historic city, as well as the modern feel of an urban community.

Geneva's early settlers built their homes, educated the children, and saw the churches as the social hub of life. The moral fiber was strengthened by these firm affiliations and strict adherence to the conventions of the times. Regular temperance meetings were held in the four Swedish/Scandinavian churches. Geneva's history is woven with these threads of many colors, and a rich tapestry has resulted.

Join me on this splendid journey!

One

A BEGINNING

HERRINGTON'S FORD

Let us watch well our beginnings and results will manage themselves.

—Alexander Clark

Geneva, Illinois, is situated in an area discovered by the French explorers Father Jacques Marquette and Louis Joliet in 1673. In 1809, the Illinois Territory was established by an act of Congress, and in 1818, Illinois was admitted as the 21st state with Kaskaskia as the capital.

To the early settlers of Geneva, their main contact with the Pottawatomi Indians was through trade. In exchange for a slice of the settler's bread, the Pottawatomi would give them one fish. Residents also sold whiskey to the Pottawatomi for other valuable articles such as knives, clothing, furs, skins, or sugar.

The winter of 1830–31 was severe. Snow fell 19 times between December 29 and February 13, and drifts piled as high as 20 feet. The settlers relied on stored Indian corn for food and the chance of finding wild game. In his autobiography, Abe Lincoln noted that the snow did not melt until "about the first of March, 1831," leaving the state "so flooded as to make traveling by land impracticable."

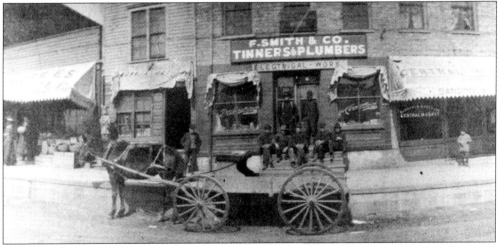

This photo of plumber Fred Smith's shop at 121–3 West State Street in Geneva was taken around 1905. By 1907, Fred was elected to the board of directors for the "temporary organization of the Geneva Bldg. & Loan Assn." The group wanted to locate factories in Geneva. In February 1907, the members had collected monthly dues and fees of $615. The Geneva Building and Loan Association was chartered as a mutual association with capital stock of $300. There were 52 subscribers to the first series of shares. All money was required to be loaned solely on Geneva properties. (Courtesy of Nancy Bell.)

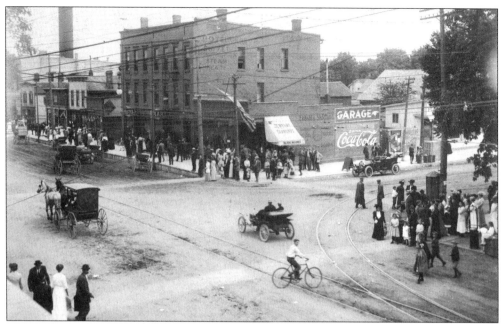

This is a view of State and Third Streets in 1911. Haight had sold his claim in 1835 to James Clayton and Charity Herrington. The Herringtons were influential in the creation of the town of Geneva. The Herrington homestead was the center of Geneva for many of its early years. His shanty store carried items that were needed for frontier life: Axe heads, garden tools, whiskey, calico, iron pots and pans, and seeds. James and Charity's ninth child, Margaret, is considered to be the first child born in Geneva. (Courtesy of Geneva History Center.)

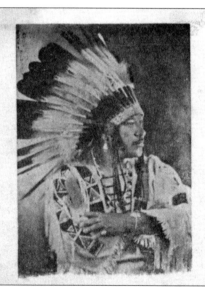

CHIEF WHITE FEATHER

SIOUX INDIAN CHIEF

PREACHING, SINGING, PLAYING

May 1, Thru 6th

First Baptist Church

Anderson Blvd. At Hamilton Street

GENEVA, ILLINOIS

Services Each Evening at 7:45 p. m.

Children's Meeting Friday Afternoon

Pictured is an announcement of the visit to Geneva by Chief White Feather of the Sioux Tribe, *c.* 1840s. Sioux country was west of the Geneva territory and there was much resentment between the Sioux and the Pottawatomi, who lived in this area. All was peaceful until 1832, when the Black Hawk Wars and subsequent treaty sent the Native Americans to the outpost of civilization at Fort Leavenworth, Kansas. (Courtesy of the Geneva History Center.)

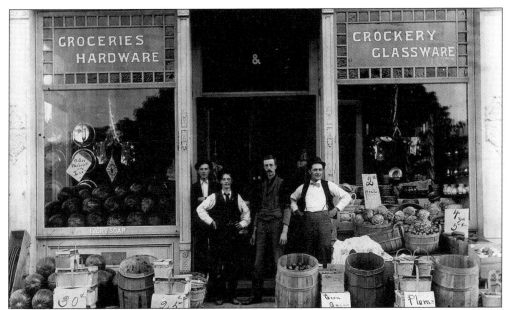

By 1840, Geneva had a courthouse and jail, a classroom and a teacher, a post office, a sawmill, three general stores, a furniture and coffin maker, two blacksmiths, one doctor, two hotels, and a tavern. A general store selling groceries, hardware, crockery, and glassware is shown here in 1895. It is Geneva's best example of a commercial building with a false front of galvanized stamped metal. One of the four men is Frank Payne, who later started his own grocery and hardware store at 207 West State Street. It later became Payne Hardware and was operated by his grandsons. (Courtesy of Geneva History Center.)

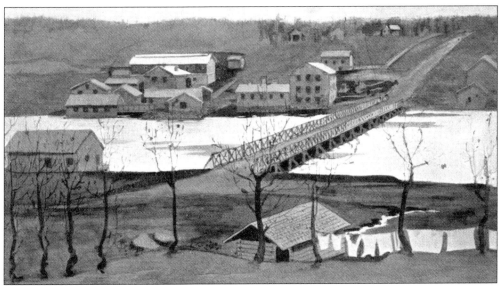

The J. Manz Co. of Chicago made this daguerreotype of a river scene in Geneva, Illinois, in 1850, for the 1897 edition of the Geneva Republican's Souvenir Edition Booklet. To the east is the Danford Reaper Works. Just north of the wagon bridge is the paper mill. A quarry site and Alexander's blacksmith shop are situated at the river's edge. (Courtesy of Geneva History Center.)

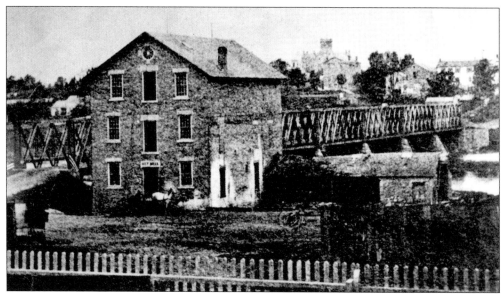

Around 1865, the paper mill became the Bennett Mill. In 1881, Charles Bennett sold his interest to his son-in-law Charles W. Gates, and the mill became known as Bennett & Gates. Government restrictions during World War I were put on the milling of white flour. The mill's popular line of self-rising cake and pancake flours was thus affected. Bennett increased production of other grains, but the decline was irreversible. After Fred Bennett's death in 1933, the mill was no longer a viable industry. (Courtesy of Geneva History Center.)

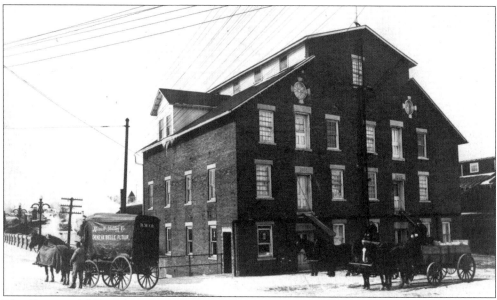

The Bennett Mill is shown c. 1911–12. As early as 1834, settlers staked their claims on unsurveyed government land. Dutchman Daniel Shaw Haight was the first settler of Geneva. He built a cabin near a spring by the Fox River in 1833. Haight's home was so dingy that new arrivals lived outside. Just west of Haight's shanty, Frederick Bird constructed a double log house from native oak. He put in a white ash floor and butternut shingles for the roof. (Courtesy of the Geneva History Center.)

Mrs. Alison Templeton Binnie was born in Airdrie, Scotland, in 1776. In 1848, following her husband's death, she and her family sailed to America on the ship *Khatadin*. They arrived in Kane County, Illinois, where they raised dairy cattle and sheep. At the time of her death in 1866, she had over 50 great-grandchildren. She is buried in Kane County. (Courtesy of Barb Norbie.)

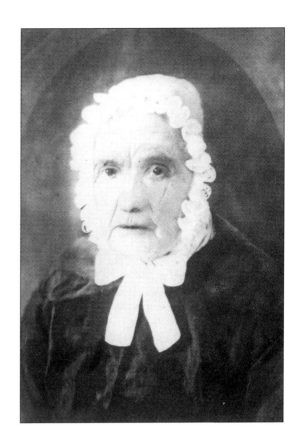

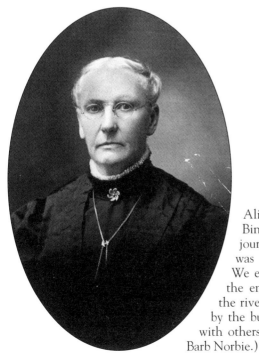

Alison Binnie's great-granddaughter was Alison Binnie McLean. From Alison Templeton Binnie's journals we read that "Everything the family used was made by hand. We made candles and soap. We even made some of our furniture. The folk of the entire neighborhood would gather together at the river and seine for fish. The fish were dragged in by the bushel. They were divided and salted. Sharing with others was the spirit of the frontier." (Courtesy of Barb Norbie.)

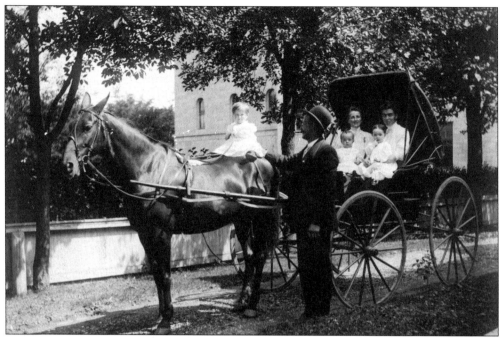

The Keiser family is seated in the buggy in front of the Strader House, west of the Third Street School, c. 1906. (Courtesy of the Geneva History Center.)

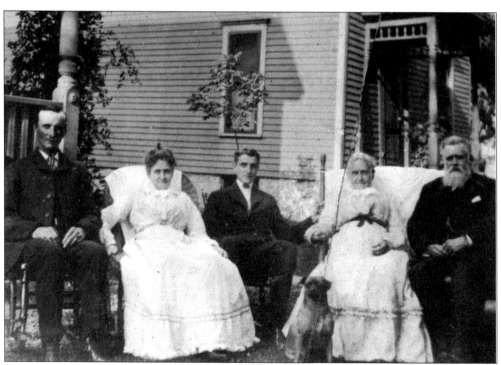

The Frank Jarvis family sits on a fine summer day in 1908. Pictured from left to right are the following: Franklin and Lydia Jarvis; their son, Frank R. Jarvis; his grandmother and grandfather, Francis S. and Jane Jackson Wrate. (Courtesy of Geneva History Center.)

The Nels O. Lawson family in a formal pose in March, 1887. The children are Julia, Willie, Adele, and Florence, shown here with his wife. The Lawson family may have just returned from viewing a silent picture or vaudeville show. Joseph Emma, of Italian descent, was manager of the Fargo Theater during the 1920s. Joseph also tried unsuccessfully to offer a "Conservatory of Fine Arts" in the theater and offered "lessons in music, dancing, drama, drawing, languages and literature." (Courtesy of the Geneva History Center.)

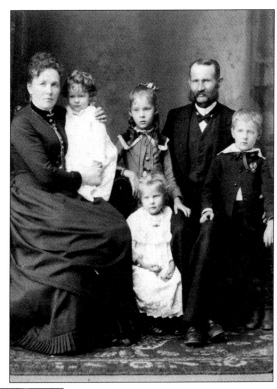

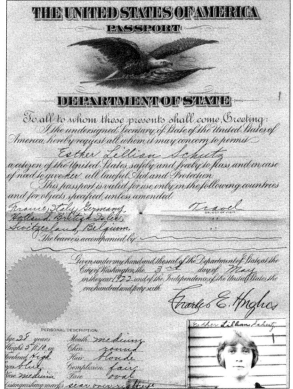

The U.S. Passport of Esther Lillian Schutz, 1922. Esther traveled to France, Italy, Germany, and other European destinations. At that time she was 28 years old, having been born in Geneva in 1893. Miss Schutz was a lifelong Geneva resident. She taught elementary school before retiring in 1959. She was a member of St. Peter's Catholic Church in Geneva, where she was the first organist. Esther lived to be 91 and died on Sunday, August 18, 1985. (Courtesy of Nancy Bell.)

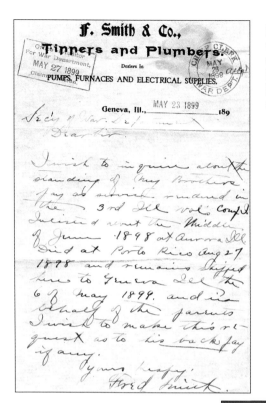

F. Smith & Co.,
Tinners and Plumbers,
Dealers In
PUMPS, FURNACES AND ELECTRICAL SUPPLIES.

Geneva, Ill., MAY 23 1899 _____189

[handwritten letter]

Fred Smith and Co., Tinners, and Plumber were dealers in pumps, furnaces, and electrical supplies. His letter request for his brother's back-pay information from the U.S. Secretary of War is dated May 23, 1899. (Courtesy of Nancy Bell.)

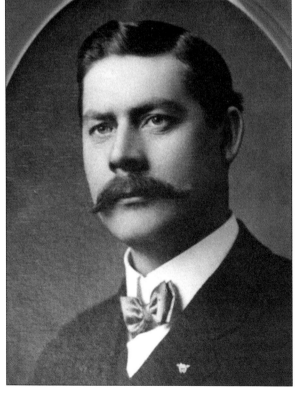

Fred Smith was born in October, 1871, in Chicago and died in 1934 in Geneva. His trade was plumbing and tinsmithing. His customers at the time included "Candy Pete" Johnson, whose candy store sold chocolate mice, 10 for 1¢, and John Soderstrom, the lamplighter for Geneva from 1890–98, when electricity was brought to town. The lamps had to be filled with kerosene and the wicks trimmed. (Courtesy of Nancy Bell.)

Catharine and Lizzy Smith sit with their cousin, Helen, on a lovely summer day in 1917. The summer blended smoothly into autumn, but the winter was bitter cold. A Woman's Council of Defense was formed in Geneva to help conserve food locally for the war effort. Rationing was instituted for sugar, shoes, and other commodities. Mayor Oscar Nelson organized Geneva's Home Defense. (Courtesy of Nancy Bell.)

Catharine Smith poses in a winter coat with fur collar in 1921. That year saw many changes in manners and morals. "Women's skirts are going up and morals are going down," proclaimed a sage of the day. Women were being hired at Marshall Field's Chicago store for the first time as post-war affluence brought growth. Electric irons and washing machines were offered in 1920. Chicago residents were beginning to summer in the lovely town of Geneva, and their stately homes are still beautiful today. (Courtesy of Nancy Bell.)

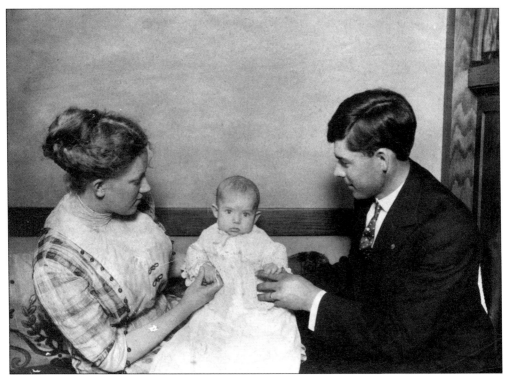

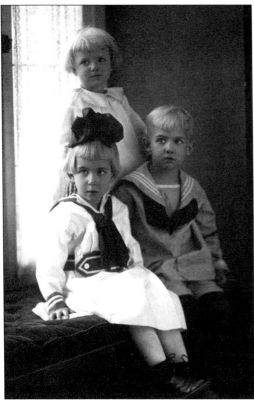

Ellen, Bob, and Bill Smith pose here in 1912. That year, Geneva had ten members on the City Council, Dr. F.M. Marstiller was mayor, and the present City Hall was built. It was also the year that Colonel Fabyan, pioneer scientist and researcher, began Riverbank Laboratories in Geneva. During World War I, his activities included decoding and deciphering enemy messages, as well as deciphering alleged secret coded messages in the works of William Shakespeare. Riverbank Acoustical Laboratories, a testing laboratory for architectural acoustics, is still considered one of the best in the world. (Courtesy of Nancy Bell.)

Helen (standing) with Mary Margaret and Bob Smith of Geneva, 1918. (Courtesy of Nancy Bell.)

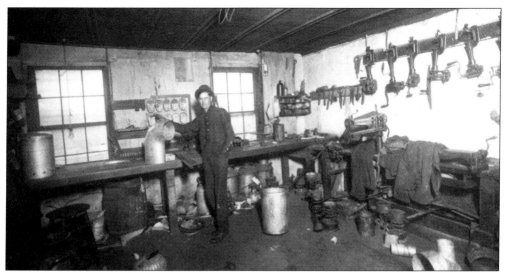

Bill Smith stands in Fred Smith's West State Street Shop in Geneva, c. 1900s. His neighbor was the Pope Glucose Company which manufactured one-fifth of the total output of glucose and starch in the U.S. in 1901. Geneva's population in 1899 was almost 2,500. Gas mains were brought in from Aurora for home cooking and lighting. In 1903, John Landers gave up his harness business and rented his office to the gas company. The automobile was replacing harnesses and hitching posts. Geneva's speed limit was ten miles per hour on city streets. (Courtesy of Nancy Bell.)

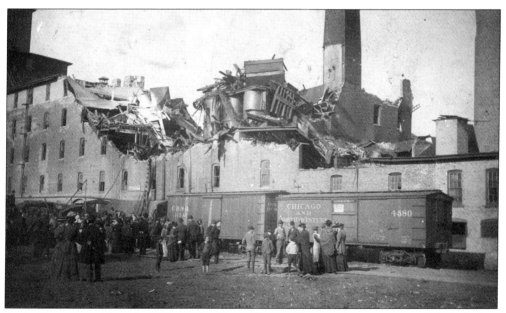

At 2:15 p.m., on May 17, 1893, at the Pope Glucose Factory, there was a terrible explosion in the corn elevator. Following this disaster, the company was rebuilt. In 1894, changes were made in the glucose works and a larger, more varied output was devised. That year, a large brick wall collapsed and the company again had to rebuild. In 1906, the Corn Products Refining Company of Argo, Illinois, bought the operations. (Courtesy of the Geneva History Center/ Donated to them by Miss Ellen Gillingham.)

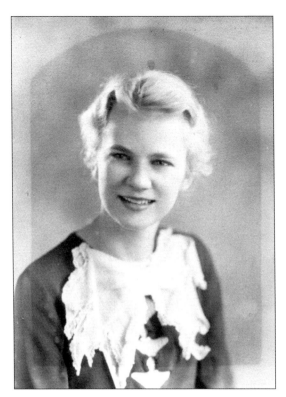

Helen may have been dancing to popular songs of the time (1932) such as "Puttin' on the Ritz," "Happy Days are Here Again," or "Ave Maria." (Courtesy of Nancy Bell.)

Helen Louise Smith Hoelscher poses here in 1920. That same year, the Little School was founded by the William Bangs family in temporary quarters at Seventh and Fulton Streets. Instruction was offered for grades kindergarten through third. In 1925, the Adventure School began in a building on four acres south of the golf course on South Street. It was renamed the Geneva Country Day School and educated students through the tenth grade. The school ceased operations around 1937, and the building became the Geneva Memorial Community Center. (Courtesy of Nancy Bell.)

Mary Margaret Smith was all dressed up for her birthday party in 1921. The event might have included a picnic at White's Woods or Nelson's Lake. There would have been fresh milk, turkey sandwiches, apples, dates, and sweets for their picnic. Mama's fudge would have been the biggest hit for Mary and her friends. (Courtesy of Nancy Bell.)

Mary Margaret Smith sits on her porch in 1932, perhaps thinking wistfully of her beaux. He might have been employed at the Smith and Richardson Manufacturing Company that produced foundry chaplets. What began in the basement soon grew too large, so the company rented a garage at 727 Ford Street, which they later expanded several times. When their first catalog was published in 1932, they offered new products for the foundry industry. Modern manufacturing methods allowed Smith and Richardson to enjoy continued success for many years. (Courtesy of Nancy Bell.)

Ellen Kenneally Schutz pictured here in 1885. The Bennett Mill, established in 1865 as a gristmill, was very successful in the 1880s and 1890s. Their "Geneva Belle" flour was sold throughout the Midwest and shipped as far away as Scotland. Ellen probably purchased the flour at the local grocer to make her biscuits, tarts, and breads. The mill closed in the 1950s and part of it was restored for office use. (Courtesy of Nancy Bell.)

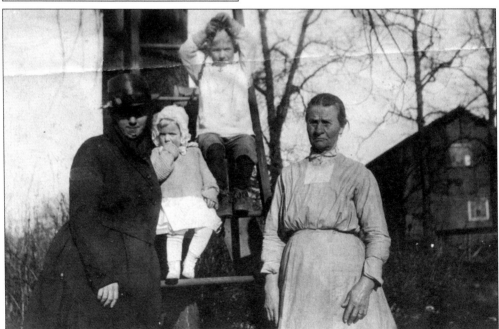

Ellen Schutz, Mary Margaret, Bob Smith, and Johanna Lena Smith pose on Batavia Street (now Chrissey Avenue) in Geneva, c. 1917. They have just returned from a Saturday shopping for dry goods and groceries. It was a cool, breezy day, so the children wore their sweaters. Dad had taken them to Geneva's Central Market earlier to purchase some Swedish meats and sausages. It was going to be a great afternoon, as the children had planned a tea party for later in the day. (Courtesy of Nancy Bell.)

Two

OF CALICO & FARMING
IN FRONTIER LIFE

Time is forever dividing itself into innumerable futures.

—Jorge Luis Borges

There is no written record of white settlers residing in the Kane County area at the time Illinois became a state in 1818. However, in the autumn of 1833, Daniel S. Haight built a log cabin near the Geneva Springs. James Herrington subsequently acquired this site in 1834. From the 1860s on, most of Geneva's industry served agriculture. The grain and dairy farmers took their products to the mills and factories. Some of those processed products included packed meat, butter, cheese, grain, glucose, and flax. The products were then shipped to the Chicago market. When the railroad came on September 12, 1850, life in Geneva changed forever. As farmers prospered, farm machinery helped milk cows, till soil, churn butter, and bring in the harvest. The Geneva Butter and Cheese Manufacturing Company in 1888 processed 18,000 pounds of milk each day. By 1977, there were only 19 farms in Geneva Township with a total acreage of 3,308. Corn, soybeans, oats, and alfalfa were the major crops.

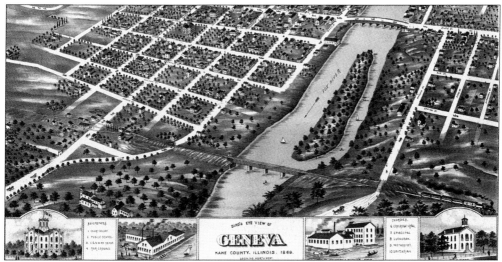

The evening lingered in this bird's-eye view of Geneva, *c.* 1869. In 1790, Knox and St. Clair Counties were fixed from the Northwest Territory. On January 16, 1836, Kane County was created. Kane included the present counties of Kane, DeKalb, and part of Kendall. Kane was named for Elias Kent Kane, a pioneer lawyer, territorial judge, prominent member of the Constitutional Convention of 1818, the first Secretary of State for Illinois, and later a U.S. Senator. (Courtesy of Lawrence A. Hagemann.)

Mr. and Mrs. William H. Tripp

announce the marriage of their daughter

Sarah Jane

to

Mr. Arthur J. Fisher

on Wednesday, March fifteenth

nineteen hundred and twenty-two

Sennett, New York

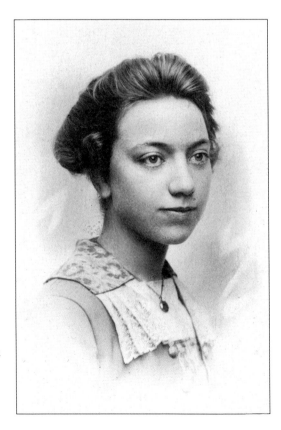

Sarah Jane Tripp's engagement photograph celebrates the occasion of her pending marriage to Arthur Fisher on Wednesday, March 15, 1922. (Courtesy of Art and Eleanor Fisher.)

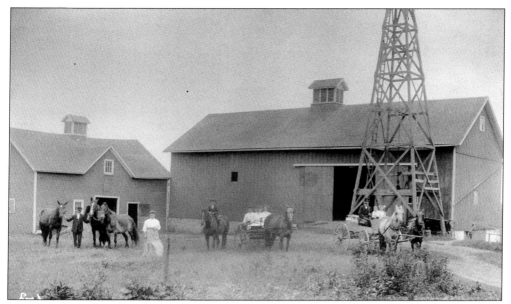

In 1900, the Fisher farm was still without a silo. Farmers had to dig wells for livestock and for family needs. Many kinds of fencing were used, including sod, picket, board, and wire. Neighbors joined together to fence fields and sometimes to build enclosed areas for livestock. Groves of trees and immense stretches of prairie grasses had to be cleared to make the soil tillable. (Courtesy of Eleanor and Art Fisher.)

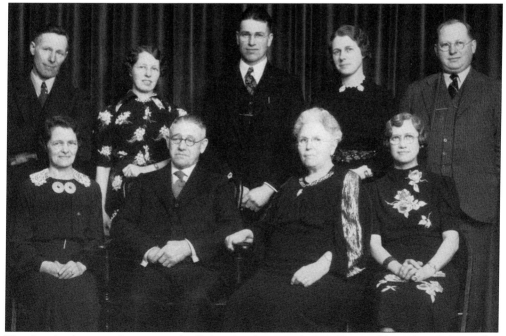

This lovely photograph captures the Fisher family around 1937. Pictured here from left to right, are as follows: (front row) Hattie, Granddad John Fisher, Grandmom Jenny, Evva; (back row) Will, Edith, Art Sr., Ann, and Lester. John and Jenny were married 67 years and had 7 children and 12 grandchildren. (Courtesy of Eleanor and Art Fisher.)

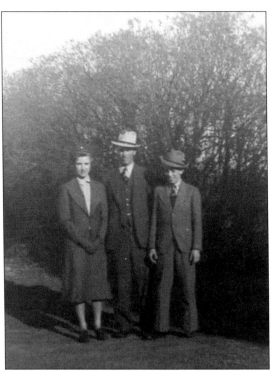

Marian Fisher, Arthur J. Sr., and Arthur J. Jr. stop for a Sunday photograph on the Fisher farm in Geneva. It is the late 1930s. A popular tune of 1939 was Judy Garland's song "Over the Rainbow." (Courtesy of Eleanor and Art Fisher.)

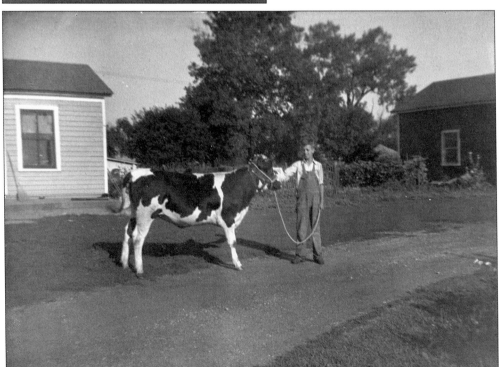

Josephine the cow was entered in the 4-H Club's annual competition by Arthur J. Fisher Jr., and she placed first. Josephine was a Holstein heifer raised by Arthur on the Fisher farm in 1938. (Courtesy of Eleanor and Art Fisher.)

Arthur Fisher was given this certificate for "unusual diligence and interest in attaining excellence" by acquiring 125 perfect lessons in the Peck School District No. 97 on May 25, 1935. (Courtesy of Eleanor and Art Fisher.)

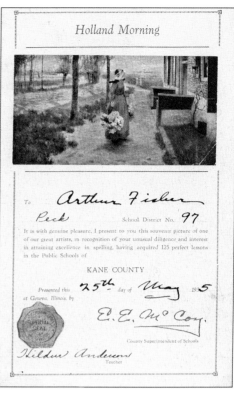

Holland Morning

To Arthur Fisher

Peck School District No. 97

It is with genuine pleasure, I present to you this souvenir picture of one of our great artists, in recognition of your unusual diligence and interest in attaining excellence in spelling, having acquired 125 perfect lessons in the Public Schools of

KANE COUNTY

Presented this 25th day of May 1935 at Geneva, Illinois, by

E. E. McCoy
County Superintendent of Schools

Hilda Anderson
Teacher

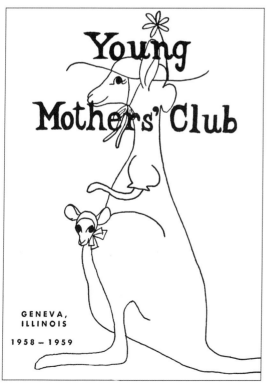

Young Mothers' Club

GENEVA,
ILLINOIS

1958 – 1959

Eleanor Fisher was vice-president of the Young Mothers' Club in 1958–59. The women had philanthropic and educational goals. They planned an annual style show, a Christmas story hour, a buffet supper dance, and an annual banquet. That year they presented a "Husband Night" and hosted Dr. Dan Q. Posin from Channel 11 TV in Chicago to speak about "Nuclear Energy and the Age of Space." At their annual Christmas Party, held at city hall, Mr. Donald Hadley presented the "Star of Bethlehem" with music by the Geneva High School Chorus. Grab bag gifts were 50¢! (Courtesy of Eleanor Fisher.)

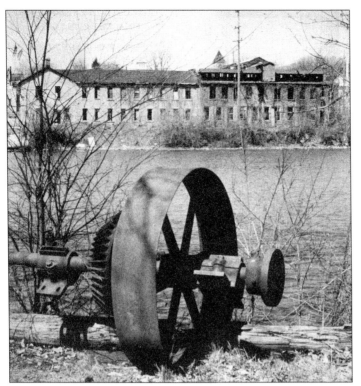

In 1854, William Howell arrived from Ithaca, New York, as a partner in Eben Danford's reaper factory. They later moved across the river to make pumps and other iron and steel products. By 1909, the Howell factory was the largest of its kind in the world. By 1936, they had moved to larger facilities in St. Charles. Later, Geneva on the Dam, a restaurant, shop, and office complex, was built around the old stone buildings constructed in 1866. (Courtesy of Margaret Hutton.)

Eli Peck was born in Bennington County, Vermont, in 1816. He started west in a two-horse wagon. He got as far as New York when one horse died. He didn't have enough money to purchase another, so he sold his wagon, traveled by water, and arrived in Kane County in 1843. By 1878, he had acquired 770 acres of land worth $65 per acre. Eli Peck died on February 9, 1892. (Courtesy of Thomas Peck.)

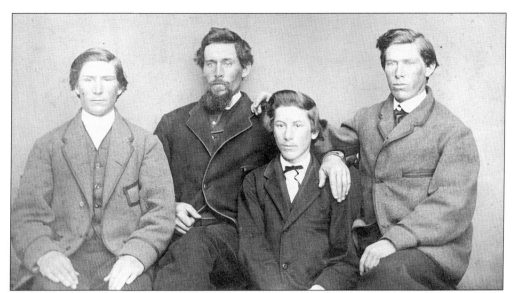

Eli Peck had four sons: George, Frank, Albert, and Seth. They are pictured here in 1860. The hardy life of these pioneers made their family strong, and hard work gave them all a long and useful existence. The *Geneva Republican*, November 18, 1893, stated that in 1866, "E. Peck and Sons purchased 75 ewes of Merino sheep. In 1869, they purchased 50 ewes from J.S. Towne of Batavia." (Courtesy of Thomas Peck.)

The four daughters of Eli and Jerusa Sherman Peck were Eta, Mary, Catherine, and Julia. They are shown here in 1860. The family moved to the large brick residence that stands on Kaneville Road and houses the Peck Farm Park. The Park now serves as a learning center. The 2002 Winter Chautauqua offered nature, computer, and map activities, as well as music by cellist Alissa Sexton and violinist Cindy Wany. (Courtesy of Thomas Peck.)

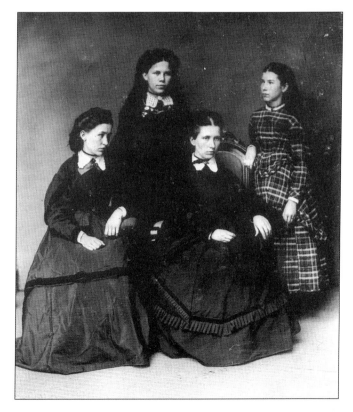

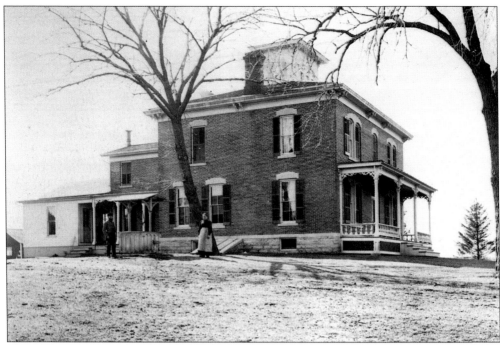

The Eli Peck brick home was built in 1869. Today, the stately, 2-story brick Italianate residence stands prominently with a magnificent view in all directions, especially of Johnson's Mound to the west and Campton Hills to the northwest. This view probably helped to alleviate the natural homesickness for the hills and mountains of beautiful Vermont. (Courtesy of Thomas Peck.)

Rena Peck was born in 1887, and was the mother of Tom, Marion, and Laurel Peck. This photo was taken in 1917. (Courtesy of Thomas Peck.)

A group of school children from Aurora, Illinois, visit Seth Peck and one of his Merino sheep. This photo is dated from the 1920s. (Courtesy of Thomas Peck.)

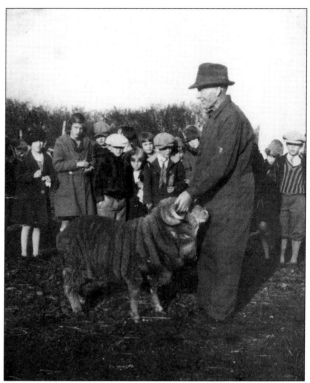

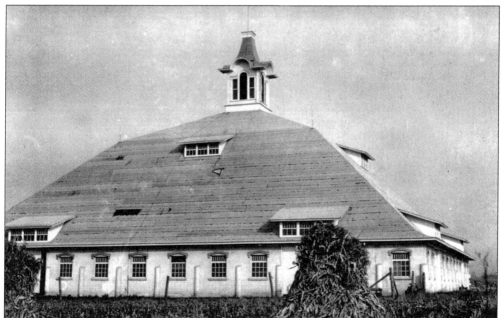

Albert Peck designed this barn *c.* 1912, and in 1914, he hired a crew of workers to finish it. This Western Avenue landmark was used by aircraft as a vantage point since there were no radios at that time. There were 160,000 feet of lumber used in its construction. It was well-lighted and ventilated, warm, dry, and clean. When making the cement walls, Peck left a groove for the windows so no wooden sills were used. (Courtesy of Thomas Peck.)

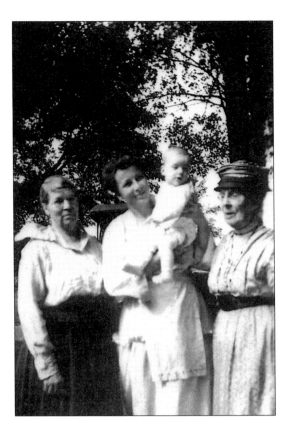

Grandma Mary Meredith Peck, Mom Rena Peck, Marion Peck (about ten months old,) and great-grandmom, Harriet Meredith, stand amid the grove of soft maple trees on a lovely summer day. They are at the Western Avenue Farm, *c.* 1919. (Courtesy of Thomas Peck.)

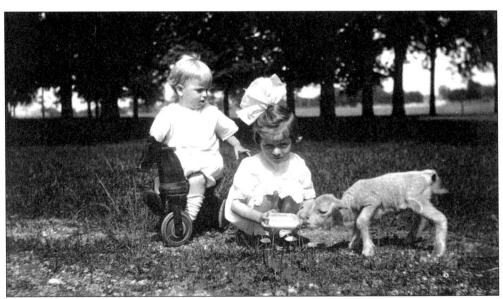

Oh, what a fine May day it was! Marion Peck bottle-feeds a small ewe as brother Thomas Peck looks on. What beautiful children! The year was 1920. Milton wrote in his "May Song" that "Now the bright morning star, day's harbinger, comes dancing from the east and brings with her the flowery May."(Courtesy of Thomas Peck.)

Seth Peck stands with his children Marion, Thomas, and Laurel in 1928. This was taken at their home on Western Avenue, which is now Eagle Brook subdivision. Seth was born on September 27, 1853, and died on March 15, 1946. (Courtesy of Thomas Peck.)

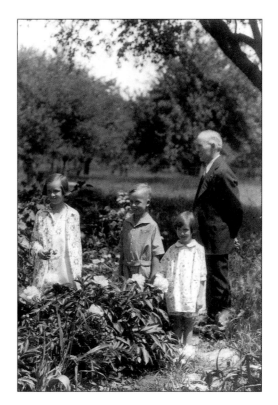

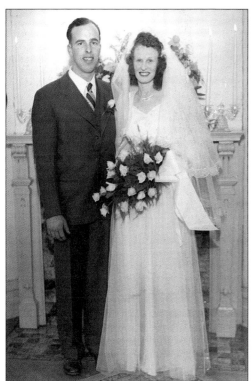

This wedding photo of Tom and Ruth Peck was taken on February 21, 1948 at their home. Brides originally wore veils to keep evil spirits away. The veil was often red for defiance against evil, or yellow to signify Hymen, the god of marriage. George and Martha Washington's daughter was one of the first brides to wear white lace, covering her head with a long lace scarf. Tom and Ruth had four children: Tom, Gary, Sheila, and Shelly. (Courtesy of Thomas Peck.)

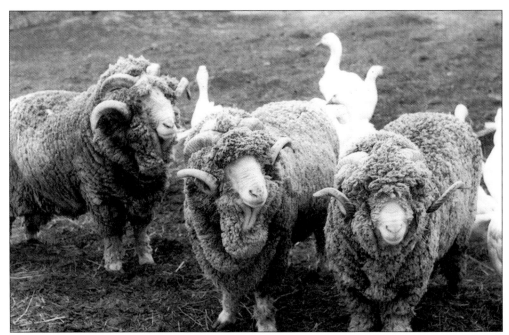

A few Merino sheep and assorted duck friends gather at the Peck Farms in Geneva. The Spanish Merino sheep produce fine wool. The Pecks' flock numbered over 3,000. The rams were sold by the carload and took blue ribbons at the 1893 Colombian Exposition Fair in Chicago and in 1895 at the St. Louis Exposition. When Eli Peck died in 1892, he owned over 1,000 acres of land. (Courtesy of Thomas Peck.)

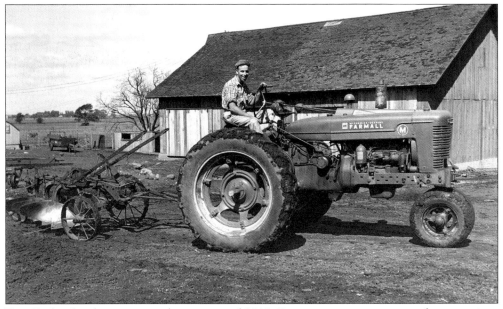

Tom Peck rides the tractor in the summer of 1948. By constant reinvestment of revenue into the Peck Farm and its sheep-raising and cattle-feeding operations over the previous hundred years, the family had shepherded their flocks into one of Kane County's most respected and prominent farm establishments. (Courtesy of Thomas Peck.)

34

Three

A CAPTIVATING SPRING

*By the third week in May, sunlight spread like a crescendo. Time expanded.
The day widened, pulled from both ends by the shrinking dark. The sky had
fallen open like a clamshell. The days were round and lighted one after the other
without end.*

—The Annie Dillard Reader

Imagine that it is 1874, and spring arrives with sunny skies and balmy temperatures. The pioneer families believed that it would be a very good year for their crops. "In the spring of 1874," one journal related, the farmers "began their farming with high hopes, some breaking the sod for corn or wheat. With plenty of rain everyone was encouraged. Neighbors would meet and visit and eat buffalo meat boiled, with cornbread and dried apple sass. The men would talk about the bumper crop they would have that year."

Stock breeding and tending was the main occupation of the Geneva farm families. Eli Peck became nationally known for the Merino sheep he raised. Another early farmer to settle in Geneva Township was Henry C. Hawkins. Henry was born in Pittsfield, Massachusetts in 1819, and came west with his wife, Sarah, in 1844.

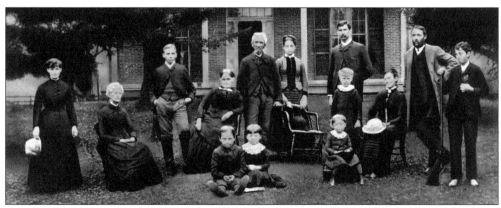

On a warm summer day, c. 1880, the Henry C. Hawkins family poses for this portrait, and are pictured from left to right: Nanum, Emily, Ed, Grandmother Hawkins, Silas, Alice, Grandfather Hawkins, Anne, William, Mabel, Katie, Aunt Kate, Uncle Henry, and Uncle Ralph Hawkins. Their home was built in 1856 and was a substantial and fashionable brick home. In 1878, he had 168 acres of land valued at $100 per acre. "With hard labor and good management it is today one of the most successful farms in the County" wrote the author in *Past and Present of Kane County of 1878.* The farm was bought by Arthur Fisher Sr. in 1900, and today is owned by his son, Arthur Fisher Jr. (Courtesy of Art and Eleanor Fisher.)

In the 1930s, Eleanor Fisher had her photograph taken by E.E. Godfrey in Aurora, Illinois. She and Art Fisher would marry on February 23, 1952, at St. Paul's Lutheran Church in Aurora, Illinois. Art had to milk the cows beforehand that day! They had two children, Daniel and Diane Fisher. Art and Eleanor just celebrated their 50th wedding anniversary. (Courtesy of Eleanor Fisher.)

Art and Eleanor Fisher receive the historic bronze registration plaque from the Geneva History Center in the 1970s. Their farm began with two 80-acre tracts that were purchased in 1845 and 1854 for $1,100. In 1886, Henry Hawkins bought a triangle of land from the Chicago and Northwestern Railroad for $100. In 1900, John and Jenny Fisher paid $14,195 for the farm. The home was built in 1856, and the story is told that bricks were hauled from Chicago by oxcart. (Courtesy of Art and Eleanor Fisher.)

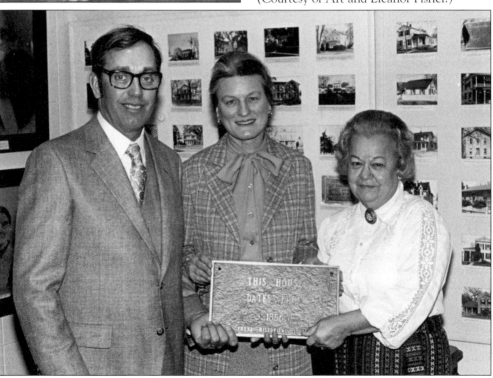

The Oscar Swan Inn was built in the late 1800s as a gentleman's farm and country getaway for Chicago banker, Oscar Swan. The exquisite home is situated on eight acres of tranquil country. The Harding family bought the home in the 1950s. Nina and Hans Heymann became the owners in 1985. With renovations and decorations of antiques, original art, silver, rugs, and wicker, it became a bed and breakfast inn in 1988. (Courtesy of Nina Heymann.)

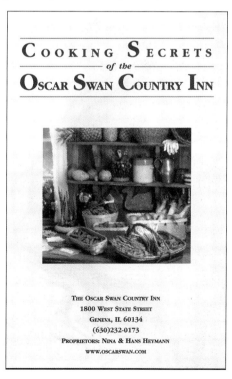

COOKING SECRETS
of the
OSCAR SWAN COUNTRY INN

THE OSCAR SWAN COUNTRY INN
1800 WEST STATE STREET
GENEVA, IL 60134
(630)232-0173
PROPRIETORS: NINA & HANS HEYMANN
WWW.OSCARSWAN.COM

Bricks found at the Oscar Swan Inn have markings of 1902 on them. This 3-story Georgian mansion along West State Street in Geneva hosts wedding showers and parties, Valentine's Day Dinners, Mother's Day Brunches, fashion shows, and other social gatherings. Ginkgo trees and beautiful silver maples are situated on the grounds and there are colorful gardens to stroll along. Breakfasts may offer fruit salad, Canadian bacon, oven-baked French toast, or frittatas. (Courtesy of Nina Heymann.)

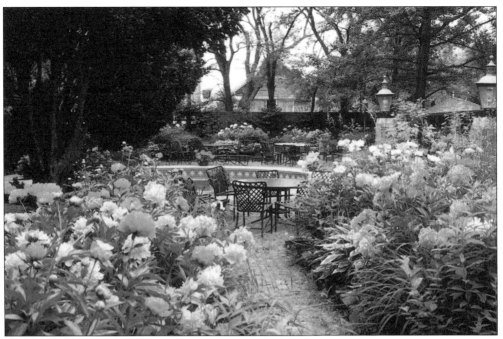

The English garden at the Oscar Swan Inn is full of splendour each growing season! A colorful palette of roses, geraniums, peonies, daisies, and many other flowers frame the 22-foot circular pool and playhouse that had been built for Oscar Swan's daughter Betty Jean. The gracious canopy of color offers the visitor a respite and a retreat from the business world at this hospitable bed and breakfast inn. (Courtesy of Nina Heymann)

THIS·IS·TO·CERTIFY·THAT

OSCAR H. SWAN

HAVING·PAID·THE·SUM·OF
ONE·HUNDRED·DOLLARS
INTO·THE·TREASURY·OF

THE·ART·INSTITUTE·OF·CHICAGO

IS·ENTITLED
TO·ALL·THE·PRIVILEGES·OF
LIFE·MEMBERSHIP
UNDER·THE·BY-LAWS·OF
THE·ASSOCIATION

CHICAGO___·_JAN·__2·_1920

PRESIDENT

William D. Tuttle
SECRETARY

Field Museum of Natural History

Chicago, U. S. A.

In consideration of the payment of One Hundred Dollars
to Field Museum of Natural History
by

Oscar H. Swan

the Board of Trustees of the Museum at a
meeting held March 10, 1924 elected him

An Associate Member

by virtue of which he is exempt from all dues
and is entitled to the privileges and courtesies
of the Museum.

Director and Secretary President

Chicago, March 10, 1924

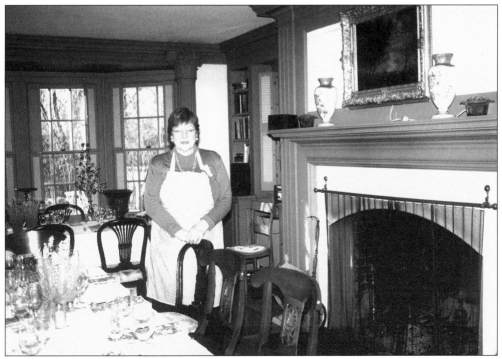

The drawing room at the Oscar Swan Inn is cozy on a December, 2001 day. Nina Heymann was serving breakfast to her guests. (Courtesy of Jo Fredell Higgins.)

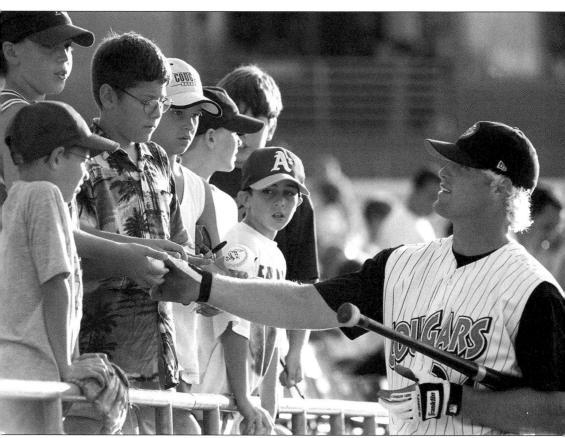

Matt Padgett of the Kane County Cougars shakes hands with a baseball fan. In 1867, the game of baseball was introduced to Geneva. The first uniformed team was called the Rovers. They played each Saturday afternoon from April to September. The members were 14–16 years old and they used regulation bats and balls. The first ball grounds, situated north of State Street in what is now the Sansone Subdivision, used sand-filled bags as bases. (Courtesy of the Kane County Cougars.)

A local Cub Scout troop posts the American flag as a game is about to begin at Geneva's Elfstrom Stadium. Since 1991, the Cougars have been one of the top attractions in Minor League baseball. John Boles, manager of the Florida Marlins, has said that "Kane County is the jewel in our Minor League system." During the 2001 home games, 16 events drew more than 10,000 fans. The Cougars set a Class A record when they drew 523,222 total fans in 2001. (Courtesy of the Kane County Cougars.)

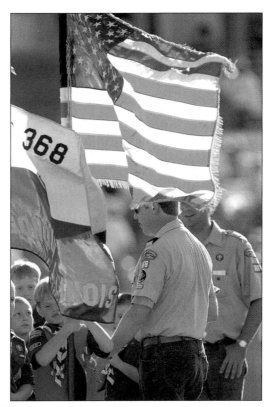

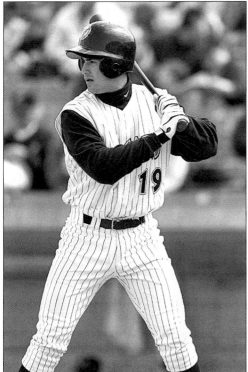

The Midwest League-winning Cougars showcased the Topps Player of the Year, first baseman Adrian Gonzalez. In 2001, he hit .312 with 17 home runs and 103 runs batted in. During the previous year, in his first season as a pro, the 19-year-old Gonzalez batted .313 with 15 home runs and 98 runs batted in. Gonzalez and three teammates were named to the league's post-season all-star team. The Cougars opened their home season against the Peoria Chiefs on Sunday, April 7, 2002. Pitcher Lou Evans signed autographs for fans between games. (Courtesy of the Kane County Cougars.)

41

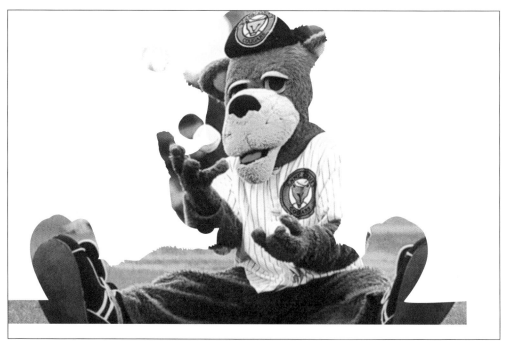

The Kane County Cougars' mascot is Ozzie. The Ozzie Reading Club is a free program for area school children and is intended to help prevent illiteracy. The Cougars provide posters, fliers, and prizes for the teachers. Over half-a-million students have read their way to rewards. The summer session, *Ozzie Roundtrippers Reading Program*, offers free Cougar souvenir items and game tickets for achievement of certain reading levels that are based on age and reading level. (Courtesy of Kane County Cougars.)

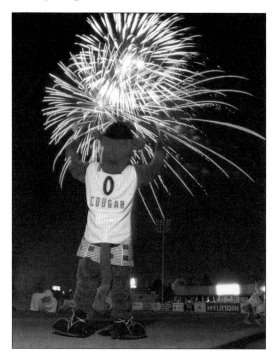

Ozzie, Number 0, celebrates last Fourth of July with a grand fireworks display. In the background is "Louie's Left Field Corner," a 3-tiered deck popular for picnics. Preferred parking, exclusive to reserved groups, is close to the deck and great for families who want to beat the crowd after the game. Other activities offered to the fans include organ donor awareness nights, church nights, seniors' nights, premium item give-aways, autograph sessions, music, food, and family fun. (Courtesy of Kane County Cougars.)

Geneva was first known as "Big Spring." The island and riverbank north and south of today's State Street Bridge was "Herrington's Ford." Travelers going between Fort Dearborn and Galena would cross the river at this point. The east bank of the Fox River and Herrington's Island has historically been an auspicious area for recreation. In 1836, James Herrington laid claim to a large portion of this area and subsequently started a mill project and the dam. In 1914, the city bought the island and designated the area as Geneva's first public park. (Courtesy of Margaret Hutton.)

Torbjorg (Toby) Hillervik, Kristine Brevik, and another friend enjoy Good Templar Park in the late 1970s. The Independent Order of Good Templars with its program of "temperance, brotherhood, and peace dedicated to the preservation of Swedish traditions" has been very active in Geneva. In January 1925, 65 acres were purchased for the park. Members did the bricklaying and built the restaurant, refreshment booths, circular stage, and picnic tables. On the third Sunday of June 1925, the first Swedish Day was celebrated in the park. (Courtesy of Patty and Earl Hanson.)

The first Swedish Day in Good Templar Park was celebrated in June 1925. Twenty thousand visitors came. Many came from Chicago on the CA&E interurban. In 1929, members of the Lodge built an athletic field, and in 1938, an amphitheater to seat 5,000. They also built summer cottages in the area. In February, 1783, Sweden became the first foreign country to officially recognize the new nation of the United States of America. A Treaty of Amity and Commerce was signed in1782. On the 200th anniversary of this event, both Sweden and the U.S. issued stamps in commemoration. (Courtesy of Patty and Earl Hanson.)

One can almost hear the song of the thrush and the rustle of the wind in the maple trees as the brook at Good Templar Park goes meandering slowly through the summer day. Rabindranath Tagore wrote that "Trees are the earth's endless efforts to speak to the listening heavens." This lush summer locale offers such scenic beauty. The country roads winding through fields of grain around Geneva are rich with the growing season. Creeks join the Fox River, which is 185 miles long, and originates about 15 miles northwest of Milwaukee. (Courtesy of Patty and Earl Hanson.)

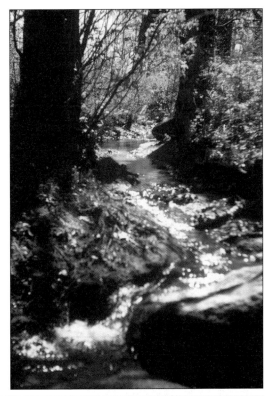

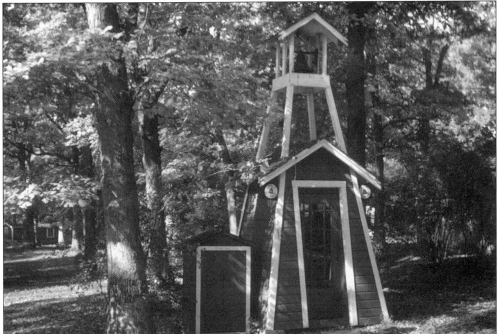

This rustic charmer houses a public telephone, a small library, and, at the top, a bell to announce meetings and programs in the community house at Good Templar Park. (Courtesy of Patty and Earl Hanson.)

The Community House at Good Templar Park is the gathering place for this summer cottage community. Smorgasbord suppers are served on long wooden boards in the schoolyard area. Fiddlers play inside the community house for round dancing. Voices, all in good spirits, sing out: "We tramp over dew-sprinkled mountains." Wildflowers are gathered and made into bouquets and to adorn the Maypole. Freshly cut birches are fashioned on the entrance gates according to an old custom. (Courtesy of Patty and Earl Hanson.)

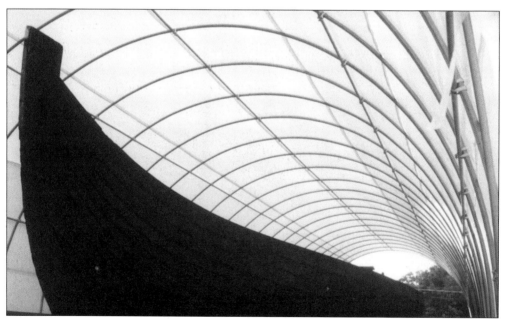

When Leif Erickson sailed west from Greenland about 1,000 years ago, hand-made sailing vessels were constructed in Gokstad, Norway. Leif had sailed with 35 men, and since he made no maps, some scientists think he landed near Cape Cod. Such sailing vessels had also been used to bury a Norwegian chieftain. Hand-made, this vessel sailed from Norway in 1893 for the Colombian Exposition in Chicago. Lincoln Park Zoo housed it for many years, until it was moved to the Good Templar Park. (Courtesy of Patty and Earl Hanson.)

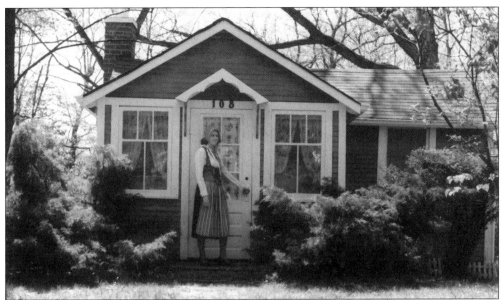

Patty Hanson stands at her front door at 108 Good Templar Park, Geneva. Music can be heard on this sweet summer afternoon. In the 15th century, the importance of music to good health was noted in a "Doctors and Herb Book." "Ye shall be happy, and not too moody, for a variety of games, song, dancing is good for the brain and good company." We read further that in the 15th century, cantors and instrumentalists were in demand at court. They occupied a special section in the royal court chapel called *Hovkapellet* in Sweden. (Courtesy of Patty and Earl Hanson.)

Male choruses are very popular with the Swedish people. Marching bands are also a lively attraction. "Life has loveliness to sell," wrote Sara Teasdale. The picturesque city of Geneva offers both the location and the environment to add to anyone's delight. Springtime plays her music within an idyllic setting of natural habitats, parks and recreational areas, modern shops, and fine restaurants. (Courtesy of Patty and Earl Hanson.)

MIDSUMMER NEWS

Celebrate Swedish Day, June 16, 1991 in Good Templar Park, Geneva, Illinois

"Flottans Män", a lively band from Karlshamn, Sweden, performs at Swedish Day this year.

Swedish Day

AT SWEDISH DAY:
"Flottans Män"—Swedish Navy Band
14 fiddlers from Chicago
Scandinavian Folkdancers
Outdoor Worship Service
Dancing around the May pole
Swedish food, gifts and crafts

IN MIDSUMMER NEWS:
Self-study group solves Swedish mystery
From Good Templar Park to the Persian Gulf
Recipies for a real Swedish Smörgåsbord

The Geneva Garden Club was founded on September 16, 1928. The first flower show was held on June 4, 1932. Members sought to beautify their homes, encourage community gardening, conserve the heritage of trees, wild flowers, and bird habitats, and—of course—exterminate weeds! Since 1972, Garden Club members have contributed flower shows, garden tours, farmer's markets, cookbooks, and the restoration of the Japanese Garden at Fabyan Forest Preserve to beautify the city's natural assets. (Cookbook from the collection of Jo Fredell Higgins.)

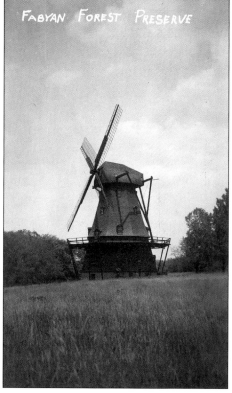

Fabyan Forest Preserve was owned and developed by Colonel George Fabyan and his wife, Nelle, from 1905 to 1936. Fascinating work was done at Riverbank Laboratories, the brainchild of George Fabyan, a wealthy cotton goods executive. With an insatiable curiosity and an estate that grew to encompass over 300 acres, he attracted the best and most capable to conduct experiments in architectural acoustics, military weaponry, codes and ciphers, plant genetics, animal husbandry, and physical fitness. (Postcard courtesy of Sue Anderson.)

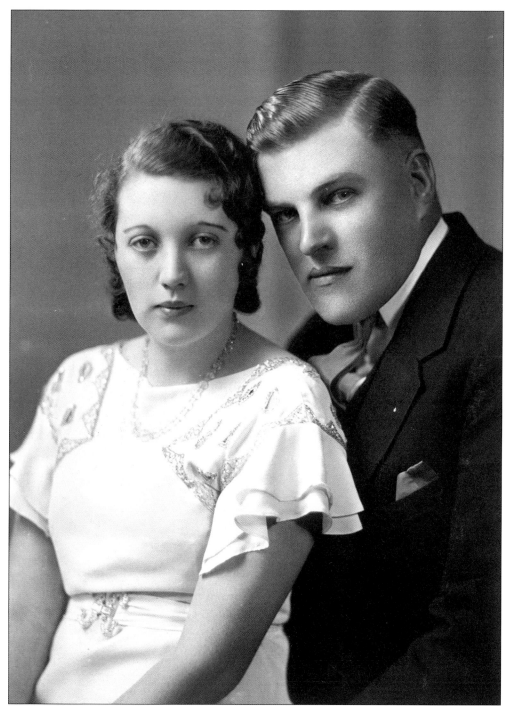

Amy and Gunnar Anderson were married on February 17, 1934. Their wedding photo is a very attractive one! The circular shape of their wedding ring symbolized never-ending love. Gold represents enduring beauty, purity, and strength which are all appropriate marriage sentiments. In 1477, the king of Germany offered his beloved a diamond as a betrothal gift, thus beginning the tradition of a diamond engagement ring. (Courtesy of Donna Peddy.)

During the annual Swedish Days parade, Gunnar Anderson served as parade marshal. His influence started at Johnson's Mound west of St. Charles in 1928. There he helped build the original ranger house. During the Depression, Anderson oversaw projects done by President Roosevelt's Works Progress Administration. In 1940, he helped clear the Fabyan estate property, put in roads, and established the Fabyan Museum. He spent 34 years at Fabyan serving as head ranger and then superintendent of the District. Gunnar died on March 4, 1993. (Courtesy of Donna Peddy.)

STATE OF ILLINOIS
SEVENTY-EIGHTH GENERAL ASSEMBLY
SENATE

Senate Resolution No. 519

Offered by Senator Mitchler

WHEREAS, Gunnar Anderson in 1928 was appointed by Dr. F. M. Maretiller as caretaker of the Elburn Forest Preserve in Kane County, Illinois; and

WHEREAS, Gunnar Anderson since 1928 has been active in forest preserves, serving as Superintendent of the Kane County Forest Preserves; and

WHEREAS, Gunnar Anderson has been affiliated with the National Park and Recreation Association and the Midwest Institute of Park Executives, serving as President of the latter association; and

WHEREAS, Gunnar Anderson has also been a member of the planning committee of the Great Lakes Park Training Institute sponsored by the Indiana University; and

WHEREAS, Gunnar Anderson has not only gained the respect and loyal support of those interested and involved in preservation of our parks and memorials, but has become one of the most loved and honored men of the Kane County area; and

WHEREAS, Gunnar Anderson has announced his retirement as Superintendent of the Kane County Forest Preserves on August 1, 1974; therefore, be it

RESOLVED, BY THE SENATE OF THE SEVENTY-EIGHTH GENERAL ASSEMBLY OF THE STATE OF ILLINOIS, that we congratulate Gunnar Anderson for his excellence in supervising and developing the Kane County forest preserves for the past 46 years and that we wish Gunnar Anderson many more years of good health and happiness during the period of his retirement; and be it further

RESOLVED, That a suitable copy of this preamble and resolution be presented to Gunnar Anderson.

Adopted by the Senate, June 30, 1974.

Edward E. Fernandez
Secretary of the Senate

William C. Harris
President of the Senate

(Courtesy of Donna Peddy).

Four

FOR REMEMBERED HONOR AND DIGNITY

A winding stair, a chamber arched with stone, a grey fireplace with an open hearth, a candle and a written page.

—W.B. Yeats

Founded in 1918 by World War I veterans, the American Legion is a veterans' support organization that focuses on the needs of veterans and their communities. The American Legion Post 75 dedicated a new post home in November, 1949. In August, they held a four-day carnival. In 1951, they held this annual event at McKinley Park. The winter of 1951 saw a record snowfall. Eight to ten inches on Christmas Eve added to a total of 40 inches that season. Post 75 continues the tradition that, for over 50 years, has honored the memory of all those who gave their lives for their country. Memorial Day is recognized with a parade and respectful ceremonies at the West Side Cemetery in Geneva. The Geneva Post's Color Guard and Rifle Squad holds an honor salute at the East Side Cemetery to those killed on land. They then proceed to the State Street Bridge for a ceremony with flowers strewn on the river in honor of those killed at sea. They then assemble at the Civil War statue in front of the old courthouse on Third Street to honor those killed in the air.

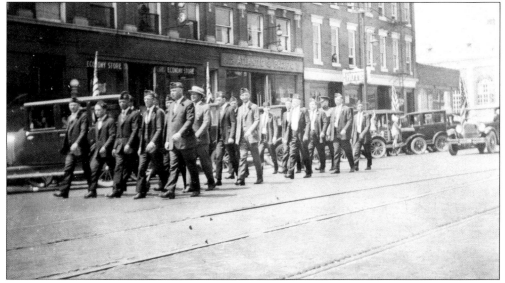

The American Legion Post hosts a parade on Decoration Day in 1925. (Courtesy of American Legion Post 75.)

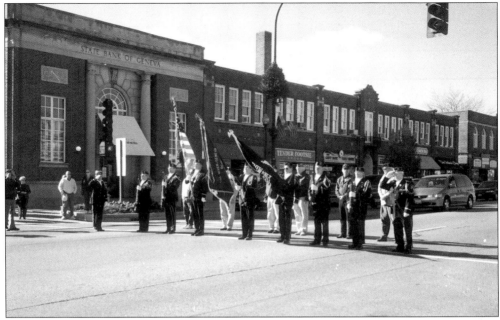

Post 75 in Geneva believes in the motto "To Honor and Serve." There are 28,000 veterans in Kane County who participate in raising money for the community. The Post holds clothing drives, pancake breakfasts, bingo nights, St. Patrick's Day dinners with corned beef and cabbage, as well as sponsors athletic teams and many other seasonal events. This photo shows a Memorial Day Parade group in the mid-1990s. (Courtesy of American Legion Post 75.)

This striking image is dated April 21, 1934. (Courtesy of American Legion Post 75.)

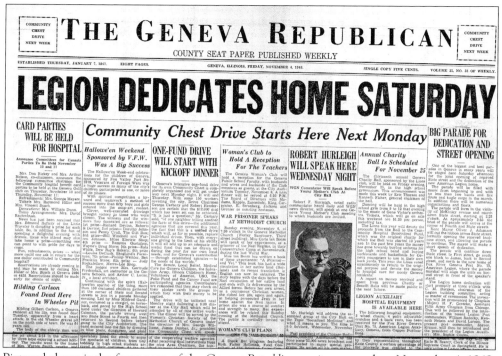

Pictured above is the front page of the *Geneva Republican* as it appeared on November 4, 1949. (Courtesy of American Legion Post 75.)

Models in Geneva participated in a "Cotton Time" luncheon and style show that was staged by the American Legion auxiliary. The Ladies Auxiliary has 78,000 members in 919 units in the state of Illinois. They also help with Christmas gifts through child welfare so that every child of a veteran receives a present. (Courtesy of American Legion Post 75.)

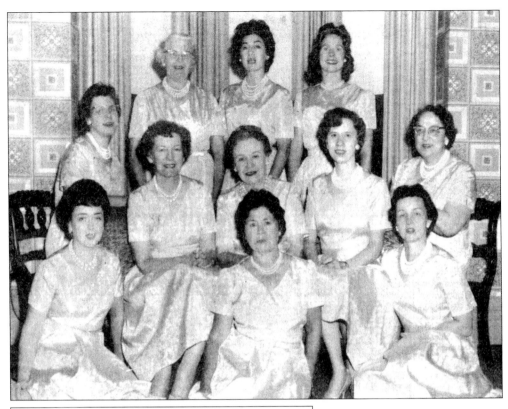

These striking ladies pose for the camera c. 1962. (Courtesy of American Legion Post 75.)

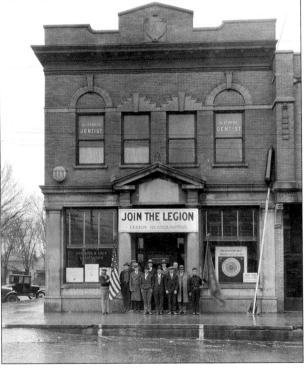

At State and Third Streets in Geneva, this group stood in front of the Legion Post 75 headquarters c. 1940s. (Courtesy of American Legion Post 75.)

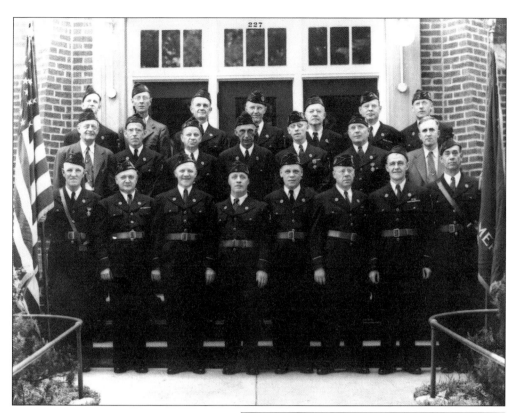

In 1944, the members of American Legion Post 75 gathered for this group photo. (Courtesy of the American Legion Post 75.)

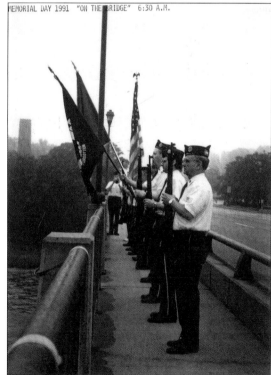

On Memorial Day in 1991, the members of the American Legion Post 75 gather for the 6:30 a.m. salute "on the bridge" for those who gave their lives at sea. Harry Turner, Dave Bieritz, and Rich Pisarcik stand at attention. (Courtesy of American Legion Post 75.)

55

The date of September 11, 2001, is forever etched in our minds. On that date, terrorists hijacked four commercial jets and flew them into the World Trade Center in New York City, the Pentagon in Arlington, Virginia, and the Pennsylvania countryside. Thousands of people lost their lives in this act of war against America. As our country continues to heal, the price that democracy has had to pay can hardly be calculated. With duty and patriotism, Americans will go forward, will grieve their dead, and will triumph. (Courtesy of American Post 75.)

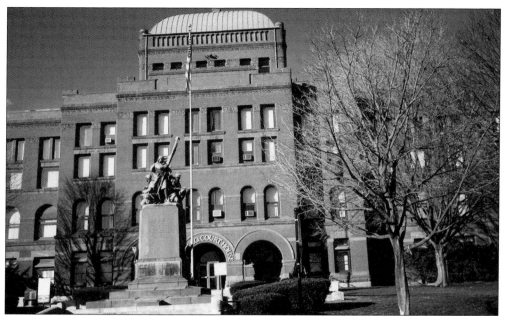

Geneva, the county seat, has had five different courthouses. The first was the log house of James Herrington near the Big Spring. On May 2, 1837, Herrington, Richard, Hamilton, and others let out bids for the construction of a courthouse and jail for $3,000. The fifth courthouse, shown here, was built of brick and red sandstone with marble trim. The cornerstone was laid in 1891. It is Romanesque in style, with an arched vault and dome. A newer courthouse has since been built west of Geneva. (Photograph by Jo Fredell Higgins.)

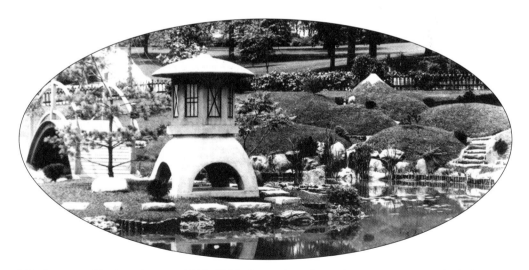

This Japanese Garden photo, c. 1915–1918, shows the eclectic Japanese Lantern, the half-moon bridge, Mt. Fugi, and hillocks in the background. Also, note the fence, which was recently duplicated by volunteers. Today, "The Villa" is a museum featuring oriental artifacts such as a 19th century Samurai suit of armor, a marble statue, and custom bedroom furniture by Edwin Elwell, which was exhibited at the Chicago Columbian Exposition of 1893. The Colonel's heirs had auctioned many items in 1939, when Nelle Fabyan died. (Courtesy Friends of Fabyan.)

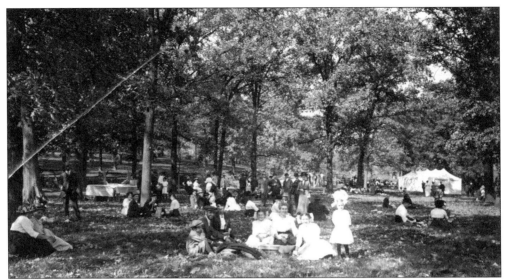

This scene could have been captured on the day of the World War I Rally held at Riverbank. Thousands attended to watch demonstrations of trench warfare and to listen to patriotic speeches. Colonel George Fabyan had bought a 10-acre tract of the Harvey farm in 1905, and moved there with his wife, Nelle. The farm grew to about 350 acres and contained a stone quarry, greenhouses, private zoo, tennis courts, cattle barns for the Jersey cattle, natural artesian wells, the Buddhist Japanese Tea Garden, in addition to the Fabyan's home. They called their estate "Riverbank," as it spanned both sides of the Fox River. Their home was redesigned by Frank L. Wright in 1907. (Courtesy of Friends of Fabyan.)

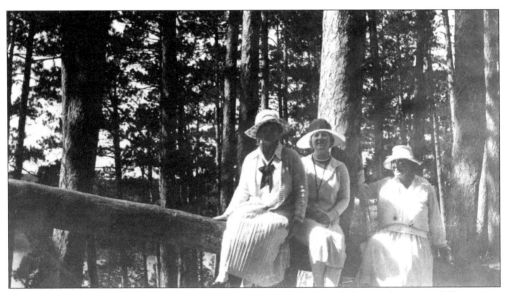

A stunning photo, indeed! The three sisters, pictured here from left to right, are as follows: Jess Harris, Leah Trott, and Nelle Fabyan. This was taken at Leech Lake in Walker, Minnesota, which was the location of their family summer cottage. Mrs. Harris and Mrs. Trott settled in Geneva, Illinois, following their husbands' military service. Mr. Harris was a physician and Mr. Trott was a West Point graduate who achieved the rank of Brigadier General. (Courtesy of Friends of Fabyan.)

Five

WAINSCOTING
& BAY WINDOWS

*Virtue and genuine graces in themselves speak
what no words can utter.*

—Shakespeare

When one strolls along the beautiful historic homes, enjoys lunch at the Mill Race Inn or Ristorante Chianti, savors the excitement of Swedish Days in June or Festival of the Vine in September, one realizes the uniqueness of Geneva. Most of the farm lands have given way to today's economic development, but still the natural beauty remains in the lovely river views along the Fox River and in the sparkling springs and nature trails. As resident or visitor, one can enjoy the wilderness-like prairie, observe wildlife or waterfowl, picnic, explore, fish, or whitewater raft below the dams. In the 1892 Souvenir of Cheever Addition booklet, one reads that "considering the great natural beauties and advantages of superior drainage, good roads and wonderful forest trees that are apparent, no greater inducements are required to settle the question of at once selecting a home now offered in…Geneva."

The Merritt A. King home was built in 1856. Merritt was elected to six terms as alderman for the City and was named Mayor Pro Tem by the city council. He is a decorated World War II Army Corps of Engineers veteran. In 1945, he married his wife, Lynne, whom he had met in England. In Geneva, they raised their three children, Bryan, Allison, and Lesley. He owned Merritt King Heating and Air Conditioning for almost 25 years. (Courtesy of Merritt A. King.)

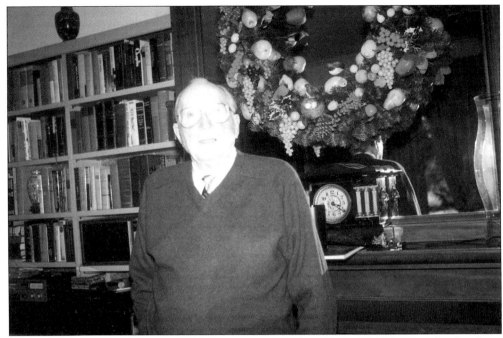

Merritt A. King was enjoying a Christmas afternoon when he posed in front of the fireplace. "Everyone should give some time to their community," he said. "It makes the community a better place for everyone." Since retiring, he has enjoyed golfing, gardening, sailing, skeet shooting, and furniture refinishing. He has also volunteered with the Geneva Township Republican Committee, the Kane County Public Building Commission, and the Tollway Advisory Committee. (Photograph by Jo Fredell Higgins.)

Longtime civic leader Merritt King served as honorary grand marshal of the 49th Annual Swedish Days Parade on June 28, 1998. King moved from Milwaukee to Geneva when he was seven. He won awards in track during high school and attained the rank of Eagle Scout. His World War II service earned the Bronze Star Medal, the French Croix de Guerre, the Air Medal, and the Purple Heart. He was named Mason of the Year in 1996, was past president of the American Legion, and has served in many capacities with the Geneva History Center. (Courtesy of Merritt A. King.)

(Courtesy of Merritt King.)

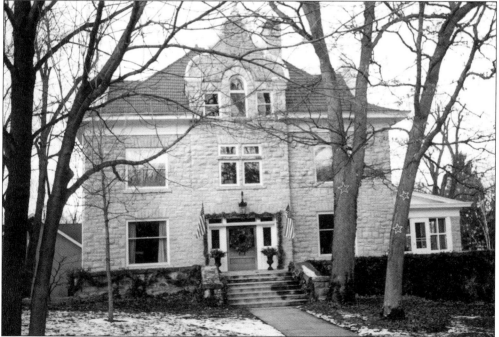

Henry Fargo liked to entertain in his regal home, a very impressive "castle" at 316 Elizabeth Place. The home was built in 1895 and is a Resurgence-style stone mansion. Immense windows allow brilliant sunshine to filter throughout the rooms. He had petitioned on September 23, 1914, to have the street name changed from Oak to Elizabeth Place to honor his first wife. Fargo and his second wife, Kate Emma Pattee, moved into the home in 1902. (Courtesy of Gerard and Janet Keating.)

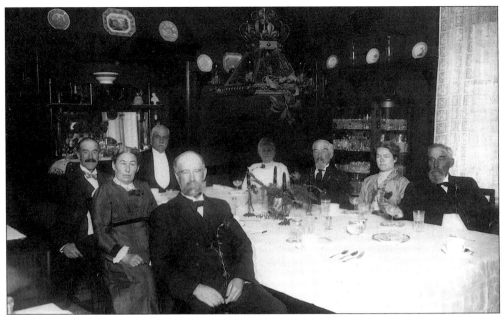

Clockwise are Albert Peck, Julia Peck, Seth Peck, H.B. Fargo, Kate Fargo, Frank Peck, Josephine Peck, and George Peck. Henry Bond Fargo, at age 40, arrived with wife Annie, daughter Orietta, and son Charles Henry in Geneva in the year 1889. The Judge Wilson home on South Street was their first residence. His real estate ventures included a shoe factory, the Geneva Hotel, the Fargo Foundry on Richards Street, and the building of the Fargo Theatre. He was a founder and president of the Geneva First National Bank at the corner of West and South Second Streets. (Courtesy of Gerard and Janet Keating.)

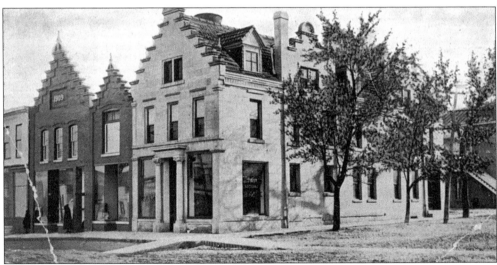

In April, 1907, Henry B. Fargo purchased the Boyes Building at the southeast corner of State and Second Streets and had it remodeled to accommodate the newly-organized First National Bank of Geneva. Mr. Egisto "Tony" Lencioni had run the Geneva Ice Cream Parlor from that location for 15 years. Also in 1908, the Geneva Golf Club put up a modest clubhouse, and the new library opened its doors at Second and James Streets. (Courtesy of the estate of Jack B. Mitchell.)

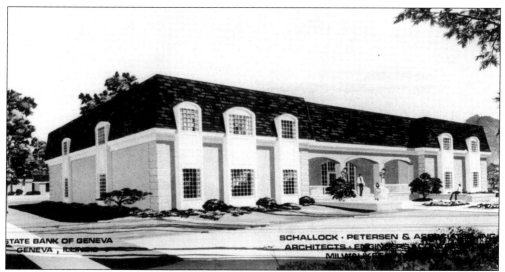

In 1888, the Bank of Geneva, an early predecessor to today's State Bank of Geneva, operated out of a butcher's shop. Owners W.H. Gaunt and C.F. Field counted change and loaned money while meat cutters sliced chops and weighed sausages at the other end of the counter! With assets of more than $28 million and thousands of clients, the bank opened new facilities at Fourth and James Streets in December, 1978. Bank President Arthur Nelson, appointed in 1975, carries on the established traditions of award-winning customer service today. (Courtesy of Arthur Nelson.)

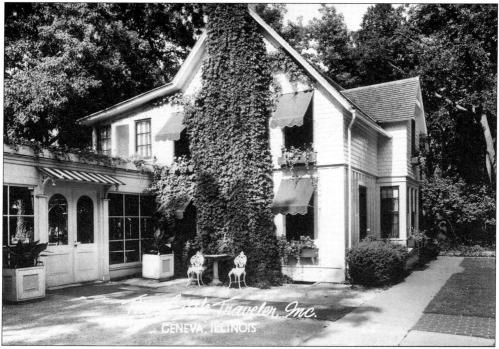

This postcard shows The Little Traveler shop, c. 1950. Mrs. Raftery opened her shop on South Third Street in the 1920s and by 1925, was serving luncheon to ladies who were driven from Chicago by their chauffeurs. Valuable antiques offered a splendid setting for these "carriage trade" ladies who could purchase fine gifts during their visit. (Courtesy of the estate of Jack B. Mitchell.)

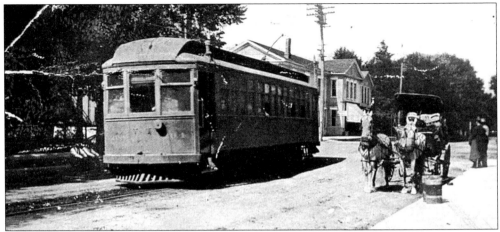

In the 1890s, Geneva enjoyed growth despite the depression of 1893–98. The Geneva Golf Course was laid out on one of the quarter sections of the McChesney farm. Alderman Updike was driving a new street sprinkling wagon. The city invested in water pipes, and in 1896, the first water was pumped from the city well. On December 9, 1896, at 7 o'clock, the fire whistle announced the first surge of electric current. A cornet band played tunes for the residents gathered in front of the power house. The first moving pictures were shown at Wrate's Hall and a billiard parlor and saloons were open for business as well. Trolley service was completed in 1901. (Courtesy of the Jack B. Mitchell estate.)

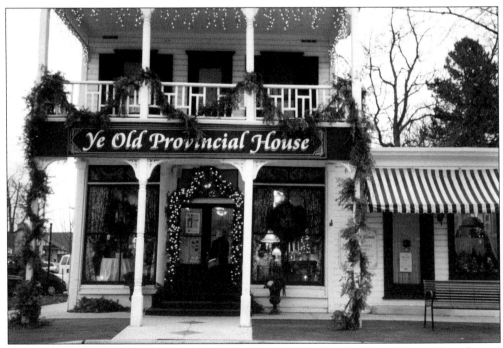

This charming building was built in 1866, according to records in the Kane County Courthouse. Provincial House is located at 101 South Third Street and records indicate that it has most likely always been a commercial building. Carriages could drive under the handsome portico to unload their customers. The building was awarded the Bronze Plaque in 1975. (Photograph by Jo Fredell Higgins.)

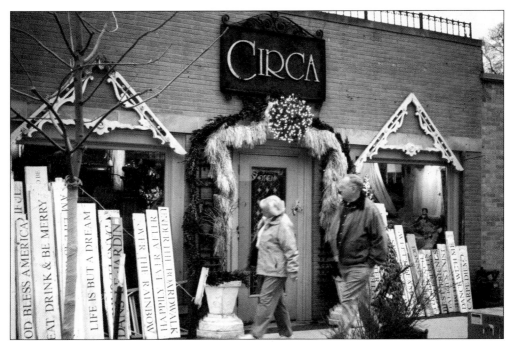

Circa is another Third Street shop that offers an eclectic mix of American and imported French objects of art. The shop also has jewelry, lace parasols, velvet purses, watering cans, ribbons, tin hearts, lamps, Easter eggs or Halloween masks, ceramic tiles, and an amusing mix of the old and new. It is a veritable feast of color, shape, and texture. (Photograph by Jo Fredell Higgins.)

Bride Lynette Hoover DeYoung is shown on her wedding day of November 14, 1992. The couple enjoyed their honeymoon at the French Country Inn in Lake Geneva, Wisconsin. Her groom, Earl DeYoung, is an engineer by profession. They moved into their Geneva townhome after the nuptials. Lynette is a graduate of Aurora University and originally comes from Indiana. Her parents are Melvin and Georgia Mattern Hoover of Wakarusa, Indiana. Lynette is a superb cook and homemaker. (Courtesy of Lynette Hoover DeYoung.)

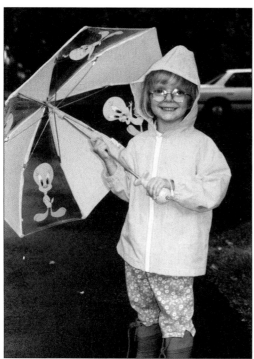

Allyson Laine DeYoung was born on February 11, 1998, at Delnor Community Hospital in Geneva. She was born at 4:39 p.m. and weighed 6 pounds, 11 ounces. In this rainy day picture, Allyson carries her umbrella. The umbrella's ancient origins can be traced back to the Orient. Umbrellas, often elaborately tiered and fringed, were carried above the heads of dignitaries during religious processions. By the 18th century, parasols became a standard accessory that indicated social or economic status. (Courtesy of Lynette Hoover DeYoung.)

Another beautiful old home is situated at 215 Crissey Avenue in Geneva. In 1852, George W. Henry purchased block three from A.B. Moore for $300. In 1853, he borrowed $1,000 and built this home in 1854–55. Now it is home to Mark and Debbie Lewis and their family. In the 1880s, the splendid home was owned by Clyde E. Mann, Geneva's first superintendent of schools, and later a riverside manufacturer of small wooden items. The home was called Hickory Hill for the many hickory-nut trees. (Courtesy of Mark and Debbie Lewis.)

Another view of the home at 215 Crissey Avenue during the winter holidays, c. 1960s. From 1906 to 1943, the poet Forrest Crissey lived here. In articles for the Geneva newspapers, Crissey wrote how Geneva "captured his heart" and represented America's best. The street the home sits on was renamed in honor of him. The home is a modified Greek revival. The exterior was originally wood clapboard. (Courtesy of Mark and Debbie Lewis.)

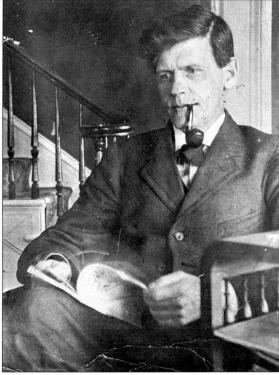

This unidentified occupant of 734 Shady Lane looks pensive, c. 1930s. Victorian Geneva is preserved in this remarkable home, designated as the Worthington-Mann home. Built in 1851 by Giles Spring, it was the first example of Italianate architecture in Geneva. Giles Spring was Chicago's first resident lawyer. The next owner was Dr. Edwin Judson, Chicago's first pioneer dentist, who paid $5,500 for the home. Today, the home belongs to Roger and Mary Sanchez and their children. (Courtesy of Mary Sanchez.)

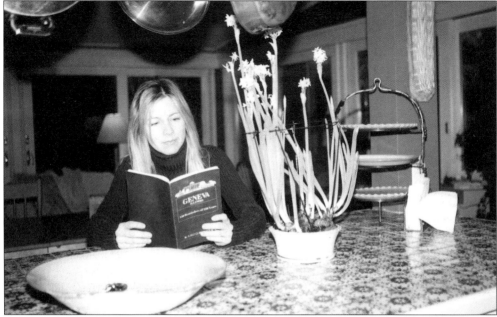

Mary Sanchez is pictured in her delightful kitchen reading a book about Geneva. The focal point of the home is the entry hall with its beautiful stained glass window. At the top of the gracefully curved staircase is a coffin niche. These were built into Victorian homes to facilitate carrying a coffin down from the upstairs bedroom where the deceased was usually laid out. The hallway has ornate grape and leaf patterned plaster mouldings. (Photograph by Jo Fredell Higgins.)

Grandma Forrest is pictured outside the home at 734 Shady Lane, c. 1890s. James Forrest had purchased the home in 1892 and owned it until 1925. The first recorded deeds to this property can be found in the Record Book I, Geneva Township, dated November 6, 1837. Giles Spring, the first owner, died on May l5, 1851. His widow was Levantia Budlong Spring, whom he had wed on Sunday, July 24, 1936, at the Episcopal Church in Westfield, Chautauqua County, New York. (Courtesy of Mary Sanchez.)

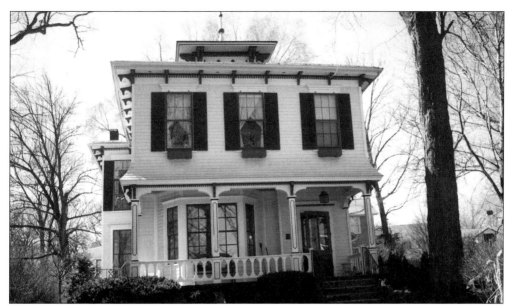

From a memoir written by Benjamin F. Taylor regarding original homeowner Giles Spring: "Seated at the theatre…the man with large luminous eyes is the Hon. Giles Spring, owner of one of the finest judicial minds that ever graced the State. Some of the beauty as well as the manhood of Chicago were there and brightened up the place like moonlight. What matters it? The footlights go out (on the stage), the players departed and the air is full of dust withal. Down with the curtain." (Photograph by Jo Fredell Higgins.)

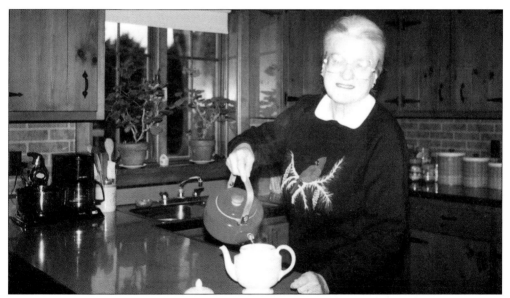

Eleanor Fisher enjoys afternoon tea in her home that was built by Henry Hawkins in 1856. We can almost hear the lingering cadence of the music from the dances that have been held in the barn for the Geneva Rotarians! Charles Monselet wrote that "The pleasantest hours of our life are all connected…with some memory of the table." Eleanor and her husband enjoyed holiday cookies and tea with me while we chose old photographs together! I shall remember. (Photograph by Jo Fredell Higgins.)

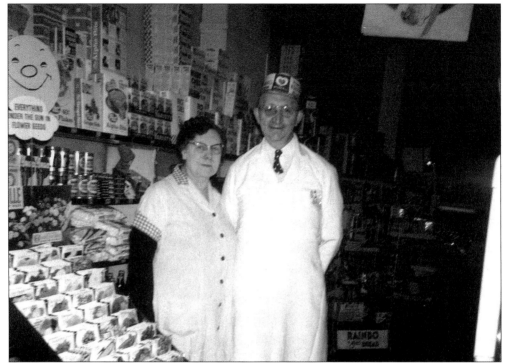

Rudy and Ruth Traike had a grocery store at 205 W. State Street, c. 1950s. (Courtesy of Margaret Martin.)

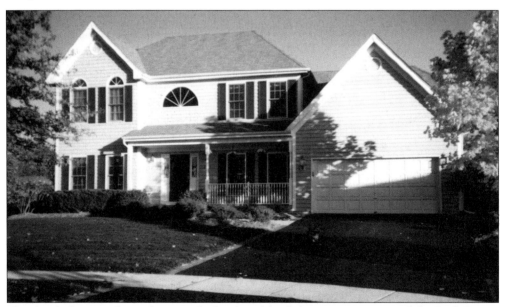

This lovely home is located on newly-developed land that was once part of the Peck Farms. Richard and Carolyn Hudspeth and their two boys, Patrick, age 13, and Andrew, age 12, enjoy their family life together in this home. Richard is a partner in the NCR Computer Corporation. Carolyn teaches at Waubonsee Community College in Aurora, Illinois. (Courtesy of Carolyn Hudspeth.)

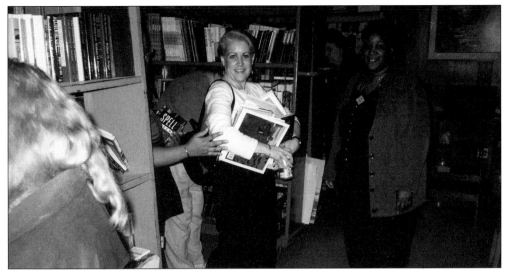

An employee of Houghton Mifflin carries an armload of books from the company's book sale. Houghton Mifflin Company, a publisher of educational books and testing products, has been located in Geneva since 1958. The property off Route 31 was formerly part of Colonel Fabyan's estate. As a reminder of the company's New England roots, the front entrance features Georgian doors and pediment. The inside glass doors picture a 1950s version of the Houghton Mifflin colophon etched in Prussian blue. Books are selected, checked, packed, and shipped to customers throughout the world. (Courtesy of Alice Hawkins.)

Enjoy this charming photograph of a robin in Spring. Peanut butter, when mixed with suet or corn meal, will attract woodpeckers, chickadees, tree sparrows, or robins. Birds that like millet include purple finches, pheasants, starlings, and sparrows. Flower seeds are enjoyed by nuthatches, blackbirds, blue jays, fox sparrows, and the grosbeak. Offer corn and the cardinals and blue jays will fly in for their tasty treats. (Courtesy of Janet Dellaria.)

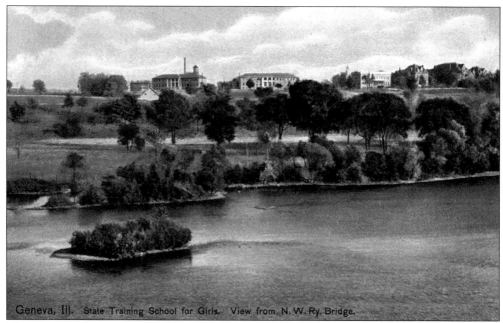

Geneva, Ill. State Training School for Girls. View from N. W. Ry. Bridge.

The summer evening lingered as the slow, meandering Fox River continued on its way. This 1¢ postcard shows a pacific scene near Geneva, Illinois, c. 1920. In government records, Geneva remained "La Fox Post Office" until 1850. James Herrington was postmaster until his death. Mail for Genevans was brought by horseback once every two weeks from Naperville, Illinois. In 1913, parcel post service arrived. The river's waterpower has been invaluable to the cities situated along its path. (Courtesy of Lawrence A. Hagemann.)

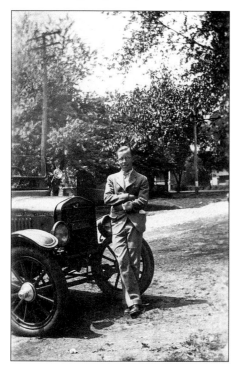

In 1927, an audience in New York saw an image of Commerce Secretary Herbert Hoover in the first successful long-distance demonstration of television. On Broadway, the musical play *Show Boat*, with music by Jerome Kern and libretto by Oscar Hammerstein II, opened at the Ziegfeld Theater. Richard Miller, looking natty and youthful at age 21, stood by his first car in Geneva, Illinois. (Courtesy of Richard Miller.)

Six

COMMUNITY SPIRIT & ORGANIZATIONS

An industrious and virtuous education of children is a better inheritance
for them than a great estate.

—Addison

In Geneva around 1835, Mrs. Cornelia Sterling began the first school in her limestone-floored log cabin. The 12 Sterling and Herrington children who attended learned the basics of reading, writing, and arithmetic. Mrs. Sterling was paid by their parents. In 1837, the school was moved to a frame building at River and Hamilton Streets. In 1838, Mrs. Alfred Churchill began an academy and sought a charter for it. She wanted to offer higher education for women. The idea was way ahead of the times and the academy did not succeed. In 1838–39, the first schoolhouse was erected on South River Lane. It was a public school supported by subscription. Records indicate that lessons were also offered in the dining room of the Geneva House Hotel. The teacher was Miss Currier, later Mrs. Richard Herrington. In 1848, a "Miss Dunham taught the children upstairs in her father's house. The stairs were on the outside and the door was so low that they had to stoop to get in."

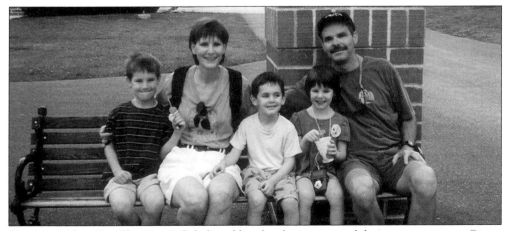

Geneva resident Dr. Christine J. Sobek and her family are pictured during a vacation to Circus World Museum in Wisconsin during the summer of 2000. Pictured here, from left to right, are the following: son Elliot, age eight; Dr. Sobek; son Eric, age five; daughter Amelia, age five; and husband Dr. Paul Anderson. Dr. Sobek became the fourth president of Waubonsee Community College on July 1, 2001. She serves on the board of directors of the Geneva Lions Club as well as many other community involvements. Her husband is an associate professor of Environmental Engineering at the Illinois Institute of Technology in Chicago. (Courtesy of Dr. Christine J. Sobek.)

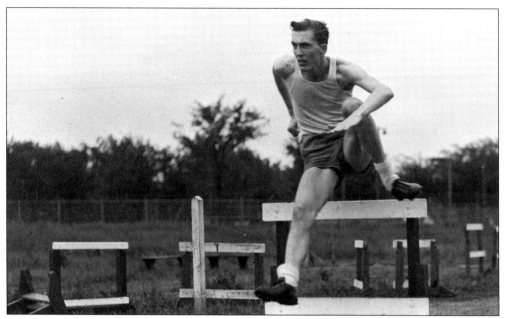

Merritt A. King held the Geneva High School record for high hurdles, relay, and discus throwing. He is seen here in 1938. He graduated in 1939. In London that same year, the National Institute of Economic and Social Research was founded. Women's Voluntary Service began in 1938, and Stalin published his *Abridged History of the Bolshevik Party*. During the war years, school enrollment in Geneva had doubled, so the board of education began to acquire land for a new building in 1949. (Courtesy of Merritt A. King.)

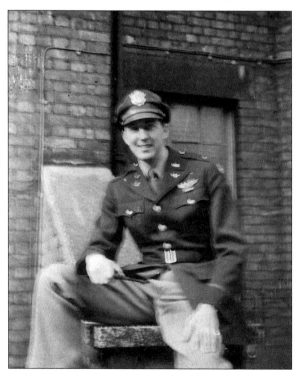

Merritt A. King is shown here in London in 1944. Merritt was drafted and served as a map intelligence engineer for six years. Prior to military service, he had attended the Lithography School and the Art Institute in Chicago. He recalls that the offices of the war college were under Oxford Street in London to avoid the bombing. He fulfilled ten aerial missions to take photographs and participated in three invasions during the war. He carried maps to the high command in Sicily and was on Omaha Beach on D-Day. (Courtesy of Merritt A. King.)

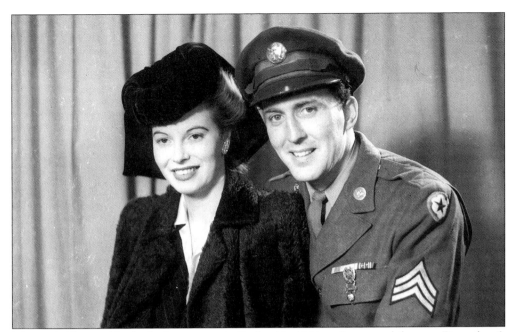

Merritt A. King and his bride, Lynne, met in England in 1944, and were wed there on December 6, 1944. She arrived as a war bride in Geneva in 1945. The couple made their home at 212 South Fifth Street in Geneva. Lynne modeled clothes and loungewear for The Little Traveler for over 20 years. They were happily married for 50 years before her death in 1994. "We sure had a great life together. We did a lot of traveling," he said. (Courtesy of Merritt A. King.)

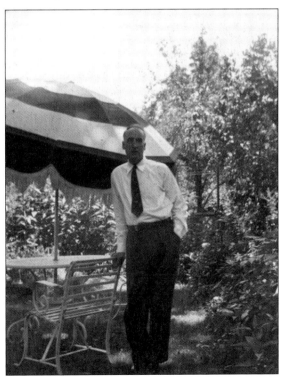

Charles George King is shown in Geneva during the summer of 1945. C.G. was an engineer and invented the piston ring. He brought the first automobile from England to Mexico. His wife was Ruth Dorcus King and their son is Merritt A. King. On April 12, 1945, President Roosevelt died and his Vice-President Harry S. Truman succeeded him. In June 1945, the United Nations Charter was negotiated with 48 nations in San Francisco. (Courtesy of Merritt A. King.)

Merritt A. King is shown here in 1919, at six months old, in Chicago, Illinois. His ancestry is Scottish, Irish, and English. His contributions to the city of Geneva are exemplary. "Geneva has an ambience unattainable by other cities," he said. Around 1970, he took it upon himself to install Victorian-style gaslights along the Third Street commercial district. "I think it adds a lot of charm to the street," he remarked. (Courtesy of Merritt A. King.)

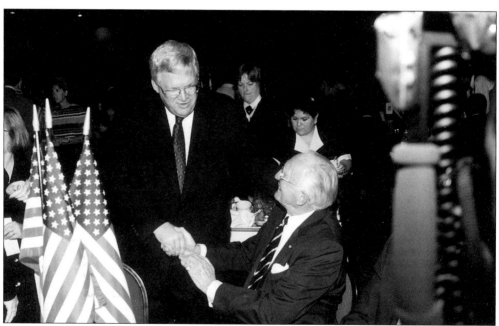

Merritt A. King shakes hands with Denny Hastert, U.S. Speaker of the House, at a recent veteran's dinner. Merritt has met most of the prominent Republican leaders of our time, including U.S. President Gerald Ford and Illinois Governors Jim Thompson and Jim Edgar. As Geneva's Second Ward Alderman, Merritt King has served long and well for the public good. He is past president of the Geneva Memorial Community Center and ran the community's pool before the Geneva Park District took it over. (Courtesy of Merritt A. King.)

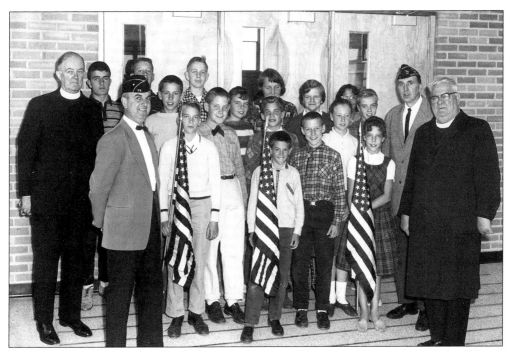

Merritt A. King is seen standing behind the Reverend French at St. Peter's Catholic School, c. 1960s. This parish school began in 1958. Fathers Ronald and Richard French, pastor and associate pastor, are the founders. They began with 115 children in grades one through six and in 1977 had 210 students. The school's first principal was Mother Virginia Marie Derk. In 2001-02, 470 students attended St. Peter's. (Courtesy of Merritt A. King.)

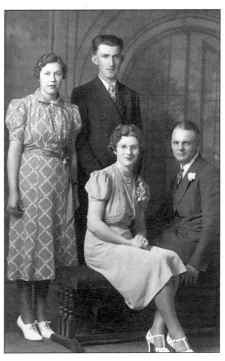

On June 4, 1938, Elmer Roper and Mildred Schuldt attended the marriage of Esther and H.P. Wessels. The happy couple is seated in this photograph. During medieval time, honeymoons lasted a month. Couples drank mead, a fermented honey drink. Honey is an ancient symbol of life, health, and fertility. When the moon waned, the couple returned to their normal lives. Hence, the term "honeymoon." (Courtesy of Esther Wessels.)

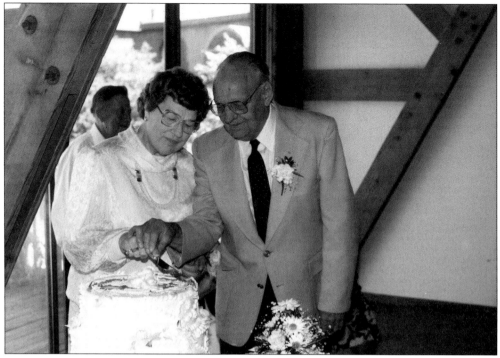

Shown at the farm at Wessel Court celebrating their 50th wedding anniversary are Herbert and Esther Wessels. The date is June 4, 1988. Wessel Court has 108 rental apartments situated on 15 acres of farmland in St. Charles. Sho-Deen Inc. purchased the land from Dr. Wessels before he retired to Wisconsin. (Courtesy of Esther Wessels.)

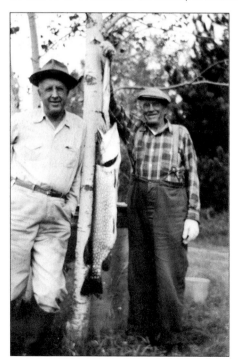

Dr. H.P. Wessels and a friend hold up their catch of the day. What a beauty they caught! The Indians used to fish in the river year-round. The Pottawatomi used spears, hooks, traps, lines, nets, bait, and seines to catch carp, bullhead, bass, perch, pickerel, and pike. Fish were dried and smoked for the winter. Fish were "found in abundance and it was not unusual to obtain in the Fox River, fish weighing 60 or 70 pounds."(Courtesy of Dick Wessels.)

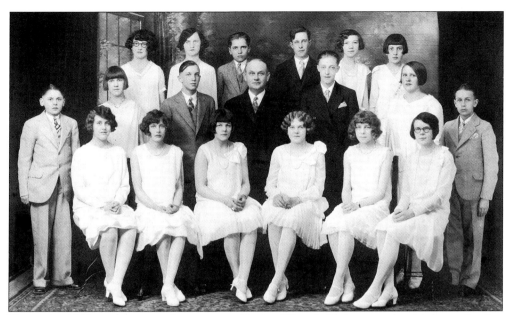

This is the 1928 confirmation class picture of Esther Wessels. Esther is in the third row, the first woman on the left of the photo. Notice the gossamer dresses, beautiful crimped hair, and suits that were worn on this auspicious day. The class attended the First Congregational Church of Palatine, Illinois. Reverend John Voecks, pastor, is in the middle. Esther is now 88 years young! (Courtesy of Esther Wessels.)

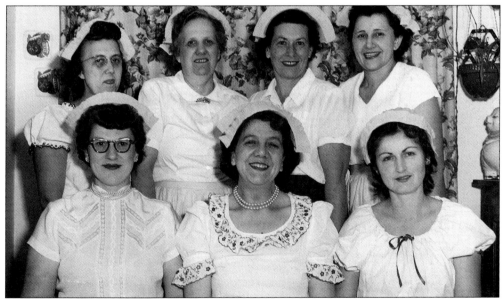

Esther Wessels, first row, first left, poses just before Geneva's Swedish Day at Good Templar Park in the 1940s. They belonged to the Geneva Chapter #952 of the Order of the Eastern Star of Illinois. Before arriving in New York, Swedes had never seen an orange or apple. The Swedish mother cooked with finesse, using spices such as dill, allspice, and bay leaf. Butter and cream were also used if the finances allowed it. An old Swedish proverb states that "food should be prepared with love and butter." (Courtesy of Esther Wessels.)

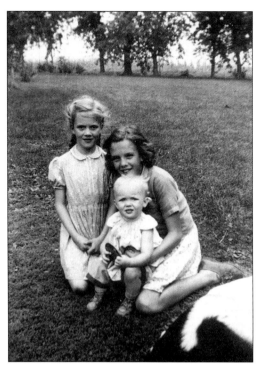

Cousins Juanita and Elaine Wessels pose with Richard Wessels in the summer of 1942. Richard was born on June 29, 1939, and weighed 8 pounds, 10 1/2 ounces. He grew up at 860 North Bennett Street in Geneva where his father, Dr. H.P. Wessels, practiced veterinary medicine. Dr. Wessels had graduated in 1936 from Iowa State University, College of Veterinary Medicine. (Courtesy of Dick Wessels.)

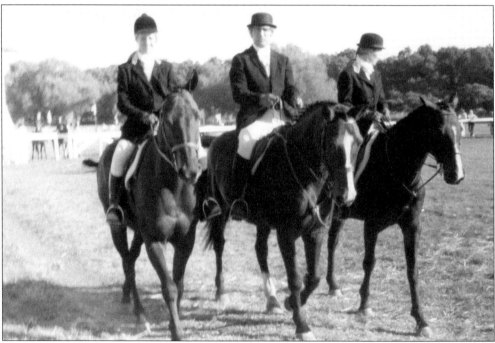

This photo was taken in 1980 at the Dunham Woods Horse Show. Jennifer, Dick, and Wendy Wessels are enjoying the ride! Wendy Wessels, owner-rider of "What A Steel" took NIHJA honors in 1978. A board member of NIHJA, Wendy rode the big gray thoroughbred to the championship in the Amateur-Owner division. She also rode at the Chicago International where she took the reserve championship in the Amateur-Owner division. (Courtesy of Dick Wessels.)

It was 1943, and Larry Moore was in first grade at Harrison Street School in Geneva. His teacher was Esther Schutz. She was also principal and at that time, first and second grades were in the same room. On December 17, 1943, The Geneva Historical Society was officially formed. (Courtesy of Lorraine Erdmenger.)

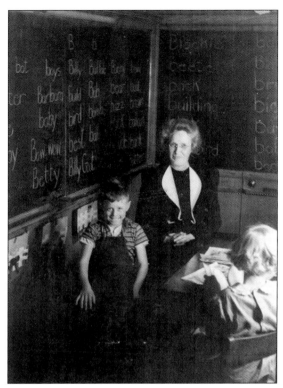

John Moore looks ever the prosperous businessman in 1895. His grandparents arrived in Geneva in 1835. Samuel Sterling, wife Cornelia Lathrop, and their two little girls, Mary and Lucy, settled in a stone-floored cabin. Samuel bought out claims on both sides of the river. By 1840, he had participated in building Geneva's largest hostelry and in the construction of a bridge and dam. Early settlers described the Sterlings as "superior people, each very energetic, well-educated, and refined." Samuel lived until 1871 and Cornelia until 1887. The Lawrence S. Moore's of Geneva today are fourth generation descendants through marriage of Samuel and Cornelia Sterling. (Courtesy of Lorraine Erdmenger.)

Nellie Moore, pictured here in 1895. On December 16, 1895, President Cleveland sent a message to Congress hinting at war with Britain over British Guiana and Venezuela frontier. It was settled by international arbitration. Cuba experienced an economic depression in part due to the U.S. sugar tariff. A hydroelectric plant was installed at Niagara Falls. And in Geneva, Illinois, life had many pleasures. People met for house-raisings, harvests, sewing and quilting bees, and later for livestock auctions. Books and newspapers, fiddle playing, card playing, and dancing were also enjoyed. (Courtesy of Lorraine Erdmenger.)

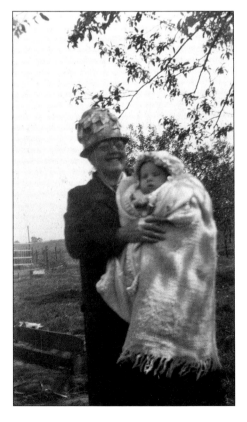

Helen Umbdenstock is seen holding Lorraine Moore in 1932. Locust Street in Geneva is seen behind them. The previous year, aviator Amelia Earhart was married to publisher George P. Putnam in Noank, Connecticut. (Courtesy of Lorraine Erdmenger.)

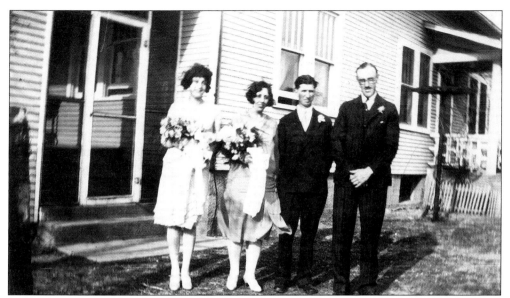

Pictured here is a scene from Helen and Lawrence Moore's wedding on April 6, 1929. Best man was Bob Kautz and Maid of Honor was Aunt Theresa Umbdenstock. In ancient Rome, the couple's first kiss sealed the contract. Another romantic interpretation suggests that when a couple kisses, parts of their souls are exchanged. Later that year, on October 24, 1929, Wall Street collapsed. Twelve million shares changed hands on the stock exchange. (Courtesy of Lorraine Erdmenger.)

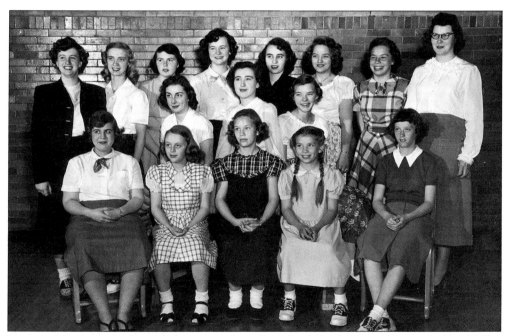

Lorraine Moore is the first person pictured on the left of the first row. This is the Fox Valley 4-H Group in 1948. They attended Harrison Street School. The previous year, the *Geneva Republican* celebrated its 100-year anniversary and took in Allen Mead as a partner. The Little Owl restaurant installed the first television set in Geneva. (Courtesy of Lorraine Erdmenger.)

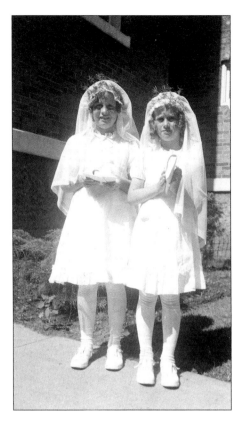

Lorraine and Barbara Moore are pictured on their First Communion day in 1939, at St. Peter's on James Street. A Yiddish proverb says that "there is so much to learn and so much to forget." At this occasion, all hopes were high and the future held great promise. (Courtesy of Lorraine Erdmenger.)

Lorraine Moore Erdmenger and daughter, Barbara, share a hug in 1958. This photograph is a treasure! Look at all the lines and angles counterpointed by the softness and circles of the people. "Tea for Two" was, once again, a popular melody that year. Lorraine might have been planning a tea party for her friends that afternoon. She could have served tiny ham sandwiches, ripe red cherries, chocolate cake, and Earl Grey tea with lemon. (Courtesy of Lorraine Erdmenger.)

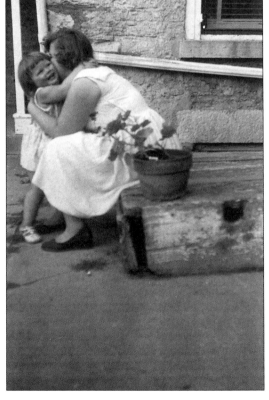

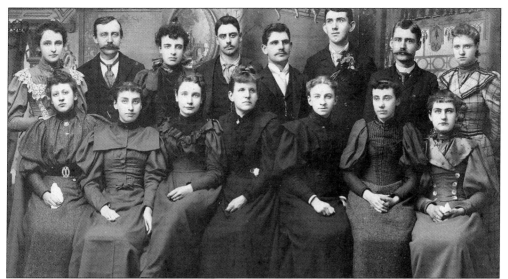

The High School of Geneva (or, as it was called, the "Third Street School") shows off the graduating class of 1893. (Courtesy of Geneva History Center.)

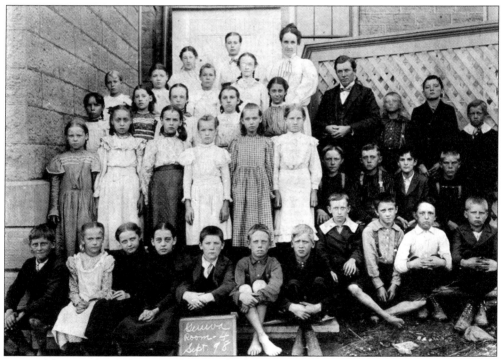

Pictured here is the fifth grade class at Third Street School in Geneva in 1898. The school was razed in 1926 to make room for the Geneva Post Office. It had been built in 1855 with a Victorian-style belfry. Some of the boys tied a string to the clapper of the bell and ran the string through trees to a block or so away. They would ring the bell late at night and from a safe distance would watch the police arrive. "We thought that was funny," recalled Tommy Thompson, graduate of 1921. "We done [sic] that for about a week before they got wise on us." (Courtesy of the Geneva History Center.)

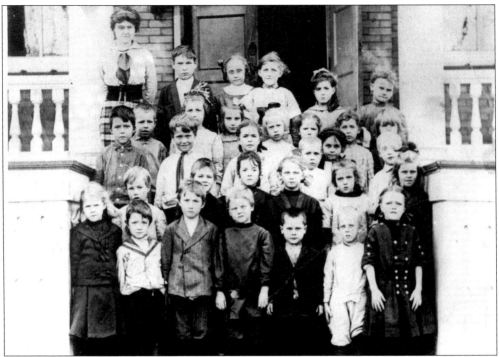

These first and second graders are pictured with their teacher, Miss Phelps, at the East Side School, c. 1913. (Courtesy of Geneva History Center.)

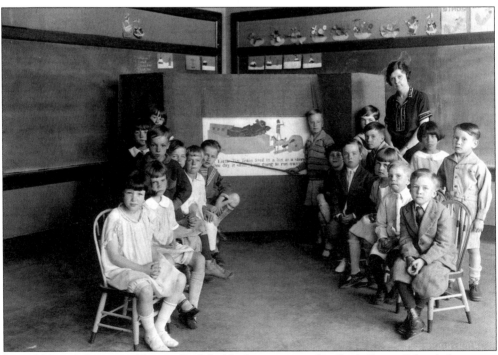

It is 1926, and the young Thomas Peck holds the pointer in his Sixth Street School classroom. I love this photograph of earnest children learning. (Courtesy of Thomas Peck.)

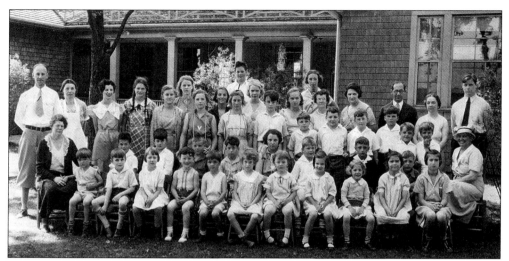

The Geneva Country Day School opened at the corner of South Street and Western Avenue in 1926. Previously, progressive learning had found a home at the Little School and then at the renamed Adventure School in Geneva. Sixty students attended during the school's peak. Its philosophy was to engage the whole child and develop all faculties rather than just fill their mind with facts. All children were exposed to science, art, music, outdoor play, dramatic play, housekeeping, and French, as well as plays and festivals. Following the 1929 Great Depression, the Geneva Country Day School closed in 1937. (Courtesy of the Geneva History Center.)

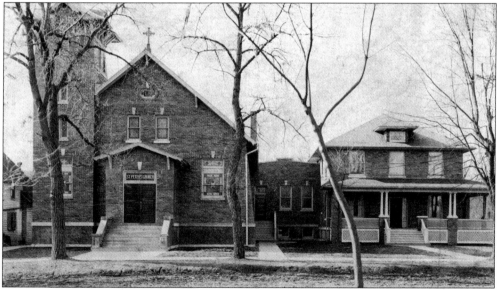

Old St. Peter's Church and Rectory stands at 500 James Street in Geneva. Mass was first offered in Geneva on July 23, 1911. The cornerstone for the first Catholic Church was laid on September 14, 1912, at James and Fifth Streets. A copper box was put in the cornerstone and contained a city directory, coins, a list of executive officers of the U.S., state and city, and a copy of the *Geneva Republican*. By March 1958, the Reverend Ronald L. French, pastor, announced plans to build on a 22-acre location on Kaneville Road. $176,000 was subscribed for the buildings and plans went forward. In the spring of 1959, there were 500 families listed as parishioners. (Courtesy of Nancy Bell.)

Anne Sexton wrote that "I am younger each year at the first snow. When I see it, suddenly, in the air, all little and white and moving, then I am in love again and very young and I believe everything." (Courtesy of Margaret Hutton.)

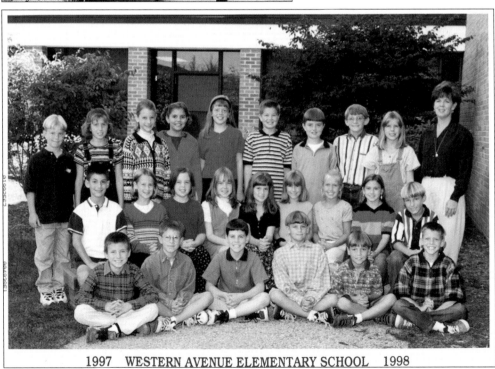

1997 WESTERN AVENUE ELEMENTARY SCHOOL 1998

Patrick Hudspeth (front row, second from right) poses with his class at the Western Avenue Elementary School, Grade 4, 1997–98. (Courtesy of Carolyn Husdpeth.)

Pictured here is the Geneva Middle School Quartet. Nancy Sexton, of the Geneva Forum for Arts and Education, was involved in a year-long project that asked area photojournalists to capture lives, people, events, buildings, situations, or landscapes in Geneva. When the project is completed, the chosen photographs will be displayed in downtown Geneva businesses. The brochure, detailing the locations of each display, will be available at Geneva's Festival of the Vine, a popular annual city event. (Courtesy of Nancy Sexton.)

This city seal was designed by Merritt A. King. (Courtesy of Merritt A. King.)

On April 17, 1816, Edward White was the first constable of the Village of Geneva. Until 1825, constables were not paid for their law enforcement services. By 1837, the Trustees of Geneva passed an ordinance that established the "Night Watch," a night time street patrol. An act of March 23, 1857, established a Chief of Police. Shown here is the current arm patch for the Geneva police. The scale of justice stands for integrity, the star designates leadership, the shamrock indicates teamwork, and the knight's head is for honor. (Courtesy of Lawrence A. Hagemann.)

For the early settlers, churches in Geneva provided not only spiritual guidance but social activities as well. Temperance was one of the main causes and the *Geneva Patrol* newspaper wrote of temperance meetings at the area churches in the late 1800s. The Geneva Swedish Lutheran Church was organized in 1853. Mr. Anderson arrived from Vastergotland, Sweden, in 1851. By 1852, he and other settlers had pledged money and obtained a small wooden building in St. Charles. In January, 1853, 34 people became charter members. (Courtesy of Thomas Peck.)

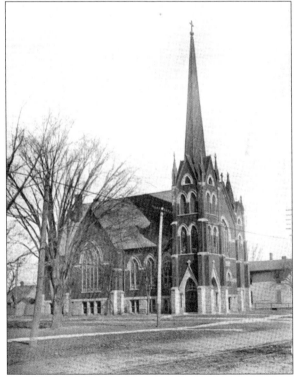

This photograph was taken at the Royal York Hotel, Toronto, Canada on September 16, 1970. Pictured here, from left to right, are as follows: Mary Burgess, F.E. Burgess, Mary Lou Burgess, Frank Burgess, Christl Burgess, and Jack Burgess. The Burgess-Norton Company was formed in 1903 by F.A. Burgess and Henry Norton. They had 25 employees and by 1912, were paying 10¢ an hour for new help. Automotive piston pins made the company the world's largest independent producer. Today, Burgess-Norton is one of the top five producers in the world of powdered metal products. Frank retired in 1982 after 36 years with the company. (Courtesy of Frank Burgess.)

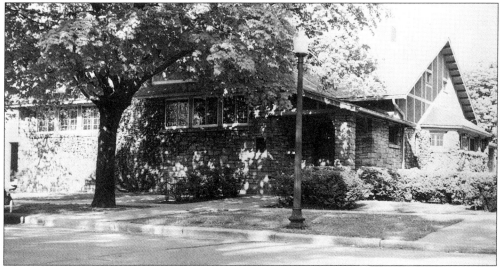

The Geneva Public Library is located at 127 James Street. The city's first library was housed in the back of a local store and included a small collection of donated books. In 1873, the Geneva Library Association was formed. Money was raised by performances of a local drama club organized by John B. Atwater. Dr. William LeBaron was president of the first library board. The population of Geneva in 1880 was 1,239. Farm-related industries included the Butter and Cheese Manufacturing Company, the Geneva Grape Sugar Company, and the Pope Glucose Company. (Courtesy of Margaret Hutton.)

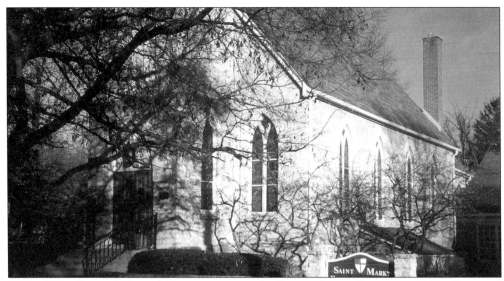

Mr. and Mrs. James (Charity) Herrington were the first settlers in Geneva, c. 1830s. Episcopal church services were held in her log house at what is now State Street near River Lane. Mary Richards Atherton and Emily Richards Lauer, parishioners in 1968 for the 100th anniversary rededication of St. Mark's Episcopal Church, were direct descendants of Charity and James Herrington. On April 25, 1898, a Consecration ceremony was held. Documents from the time note that "gentlemen of the parish wore their usual Sunday costume—morning clothes. The ladies' fashions were more colorful and every bonnet had its 'dead bird'." (Photograph by Jo Fredell Higgins.)

Pictured here, from left to right, are as follows: Father Joe Jarmoluk, pastor; Bishop Doran; Carol Jacklin; Todd Augustine; Deborah Bray, Principal; Mark Meszaros; and Kevin Burns, Geneva Mayor and a graduate of St. Peter's School. In February 2002, the groundbreaking ceremony was held at St. Peter's in Geneva. The $8 million construction project will bring the growing parish more than 60,000 square feet of new and renovated space. The church has nearly 8,000 parishioners, 470 students, and 1,500 additional students, who attend the after-school religious education programs. (Courtesy of Rama Canney.)

Seven

VOLLKOMMEN

GENEVA'S SWEDISH HERITAGE

Thought sees beauty. Emotion feels it.
Imagination furnishes that fact with wings.

—Theodore Parker

The first Swedish immigrants arrived in America in the spring of 1638. They had crossed the Atlantic on two windjammers. The colonists soon built a fort and named it for the 12-year old Queen Christina, daughter of Gustavus Adolphus II. They treated the Indians equitably and sincerely as the "rightful lords of the country." Thus they enjoyed the Indians' good will and cooperation. Their settlement was located within the present city of Wilmington, Delaware. When the Galena and Chicago Union Railroad purchased the right of way for their railroad through Geneva, Illinois, in 1852, they hired Swedes to clear and grade the land. In 1853, Swedish families settled in Kane County. By 1860, many more were living on the east side of the Fox River which was referred to as "over in Sweden." Many industries, including The Glucose Factory and the Geneva Rock Springs Creamery, had attracted the settlers. Between 1850 and 1930, 1.25 million Swedes emigrated to North America. At the time of World War I, almost one-sixth of the world's Swedes lived in the United States.

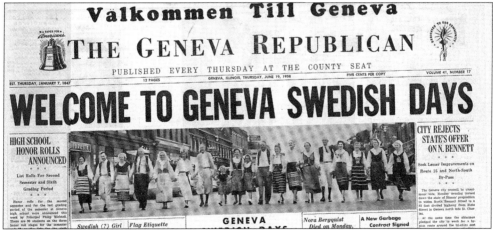

Most immigrant scholars describe the Swedish people as hard workers, lovers of nature, stoic, supportive of education, honest, and possessing integrity. The immigrant Swedes had also an ardent love of music and song. For many years, traveling troubadours had toured Sweden, literally singing for their supper and for the night's lodging. In 1885, the words to "How Great Thou Art," were written by Carl Boberg, a preacher, writer, and poet from Monsteras, Sweden. It was published in German in 1907 and in Russian in 1972. (Courtesy of American Legion Post 75.)

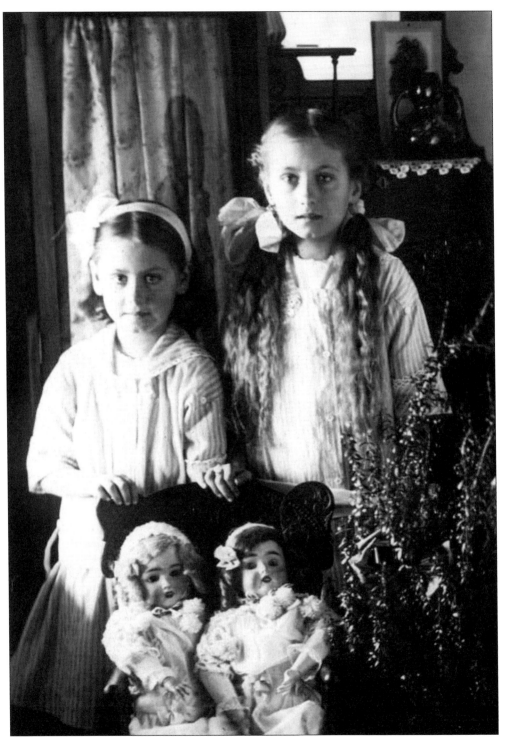

Emma Anderson, age eight, and Ida Anderson, age five, fill this remarkable photograph with all the wonder of little girls playing with their dolls! It is February 5, 1914. (Courtesy of Geneva History Center.)

Julius and Edward Alexander arrived in Geneva in 1837. They built a log building on the east side of the Fox River and forged rods for the new dam. The building was also a stone shop and a carriage shop prior to 1933, when it became a restaurant. Miss Ann Forsyth of Aurora opened the tea room, which counted Fruit Soup and Liver Pudding among its specialties. The Mill Race Inn was awarded a Bronze Plaque in 1952 from the Geneva Historical Society. Dining today is truly a fine experience at the Mill Race Inn. (Courtesy of Margaret Hutton.)

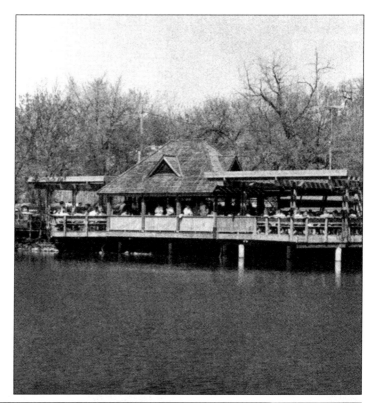

Helen Kautz Moore and Leona Stastny are shown in February, 2002, at the Pine View Home in St. Charles. Helen's family arrived in 1902 from Germany. She graduated from Geneva High School in the 1920s and helped her mom, Freda, and her dad, Franklin, with chores at their home on the east side of Geneva. She was driven to school in a horse and buggy. Her family bought dress material at Hill's Dry Goods Store at Second and State. In seventh grade, she sewed two dresses for that school year. There were only four families on their first telephone line! (Photograph by Jo Fredell Higgins.)

SWEDISH DAYS
JUNE 19-24, 1990

GENEVA ILLINOIS

In 1949, the summer festival of Swedish Days began. It was timed to approximately coincide with the summer solstice. In 1954, the Pure Milk Association joined with the Geneva Chamber of Commerce to sponsor a festival called Butter Days. After two years, the festival reverted to its original name to reflect Geneva's Swedish heritage. Swedish Days celebrations feature the costumes and culture, the arts and crafts fairs, music and entertainments, sidewalk sales and foods that reflect Swedish life. (Courtesy of Margaret Hutton.)

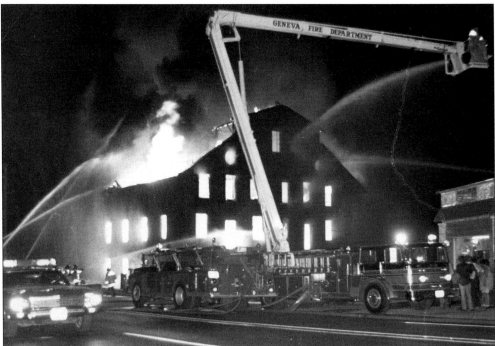

This photograph shows the Bennett Mill, built c. 1846, burning in September, 1971. In the late 1880s, fires were destroying many shops, homes, and buildings. The first attempt at civic fire protection involved running a main from the river to the corner of State and Third Streets. A 75-foot high trestle held a 30-foot water tank. Shortly afterward, the city organized a hook and ladder company. It proved inadequate for fighting fires such as the one that destroyed the third Kane County courthouse on March 13, 1890. (Courtesy of Merritt A. King.)

(Courtesy of Richard Miller.)

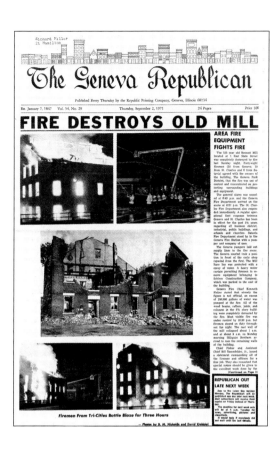

The Peck Farm family barn is ablaze in this 1969 photograph. Geneva farmer Albert Peck had engaged Fred S. Hillquist to build a sheep barn on Western Avenue. It was 1913, and the design of the barn received national attention. It was 4-sided, 148-feet square, with a contoured roof. The haymow in the center was 68-feet square and had a capacity of 1,000 tons of hay. "Peck's Barn" met this fiery fate because the land was going to be used for development! (Courtesy of Merritt A. King.)

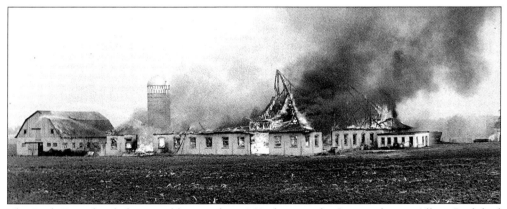

On January 13, 2002, Nolan Ryan, Scott Anderson, Mike Macaluso, Mike Benz, and Rob Stevens smiled for the camera! They are members of the Geneva Fire Department which had its beginnings in 1895, with 14 volunteers who traveled by horse-drawn wagons. Today it has over 60 professionally trained crew members. The Tri-City Communication system began in 1976, and is a communications center for emergency, fire, and police radio. With computer technology, a call can be traced immediately to verify the address and origin of each call. (Photograph by Jo Fredell Higgins.)

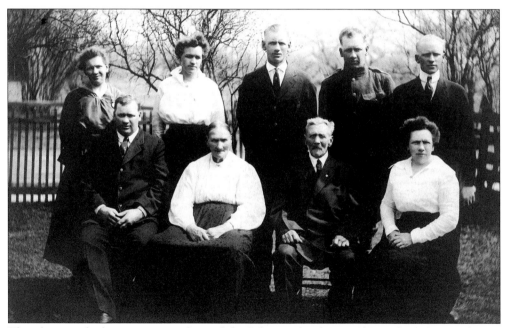

The photograph shows nine members of the Johnson family in 1917 at their Geneva home, located at 22 Nebraska Street. Pictured here, from left to right, are the following: (front row) Axel, Ingrid, John, and Ida; (back row) Julia, Mamie, Albert, Frank, and Edward Johnson. John is the oldest member, as he was born in 1829. Edward is the youngest, born in 1893. John died in 1920, and Edward died in 1977. (Courtesy of Richard Miller.)

It was Christmas Eve, 1903, when Julia Johnson and Anton Miller married. They were together for 47 years and bore 4 children. The tradition of the bride wearing something old (continuity), new (optimism for the future), borrowed (borrowed happiness), and blue (fidelity, good fortune, and love) comes from an Old English rhyme which ends with the line "a sixpence in your shoe." Notice the heart-shaped watch fob that Anton wore. Their son, Richard, has that in a memory box in his living room today. (Courtesy of Richard Miller.)

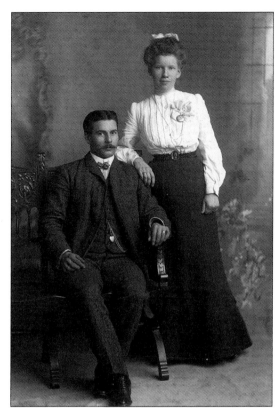

In 1905, Ingrid and John Johnson sat for this portrait. Black was an acceptable color for formal portraits of that time. (Courtesy of Richard Miller.)

What an enchanting postcard from the early 1900s! Theodore Hillquist looks like a proper young man as he touches the big saw. His son Ron Hillquist would operate a gravel business in Geneva many years later. (Courtesy of Richard Miller.)

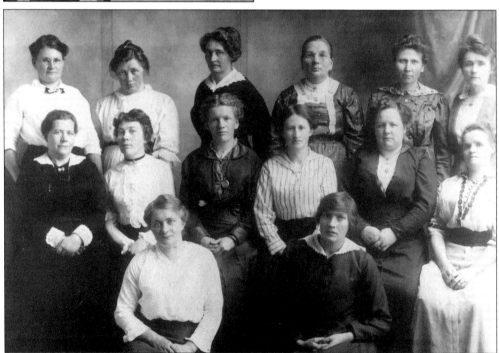

The officers of the Ladies of the Viking's pose in 1914 for this great photograph! Swedish names such as Dahlquist, Swanson, Erickson, Bloomquist, Larson, Lundgren, and Tornberg are represented here. (Courtesy of Richard Miller.)

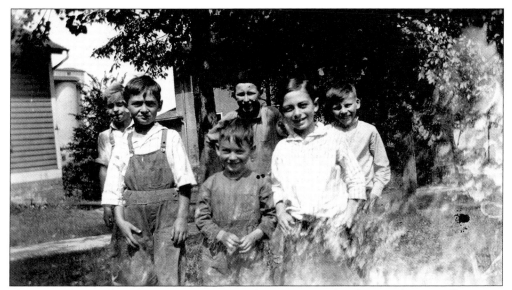

The "Hamilton Alley" boys in 1920–21. Hank Larson, Hank Olson, and Ray Miller are in the back row. Al Simon, Will Simon, and Ed Simon are in the front. With all their charming smiles, I can imagine that they were just about to make some mischief in the summer's heat. (Courtesy of Richard Miller.)

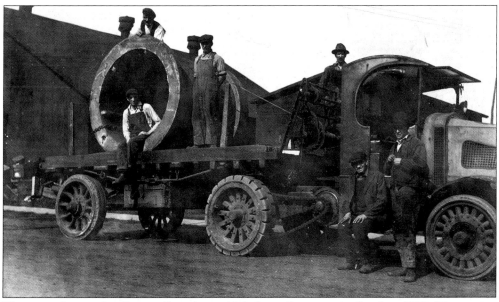

This was taken at the Geneva Foundry and Machine Company in October, 1920. The casting weighed 12,650 pounds. The truck itself weighed nine tons! The only identified men are Harry Johnson, George Williams, and Anton Miller. The rest of the crew is not identified. (Courtesy of Richard Miller.)

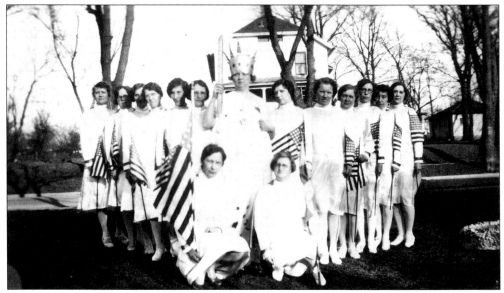

The ladies of the Viking's Drill Team are ready for an autumn parade in 1930. The women are not identified. (Courtesy of Richard Miller.)

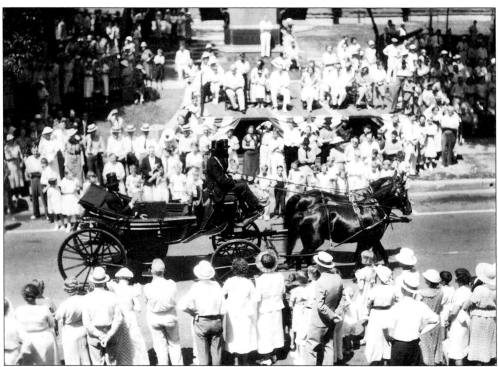

This wonderful photograph shows the Kane County Centennial Parade on July 4, 1936. About 20,000 people enjoyed the parade. The man portraying Abraham Lincoln is not identified. This is in front of the old courthouse on Third Street. (Courtesy of Richard Miller.)

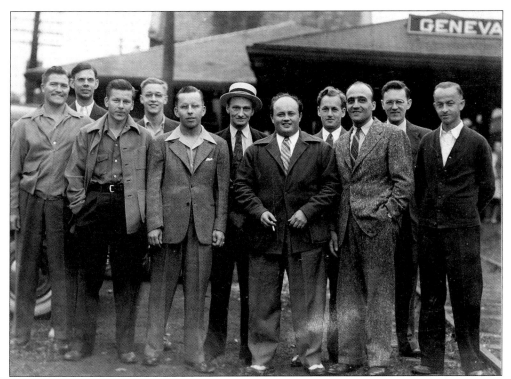

Some Geneva men are at the depot just before departing for World War II in 1942. Their names are unknown. (Courtesy of Richard Miller.)

On the occasion of their 50th wedding anniversary, Mr. and Mrs. Edward Swanson of Geneva posed for the camera. They had wed on October 24, 1896. (Courtesy of Richard Miller.)

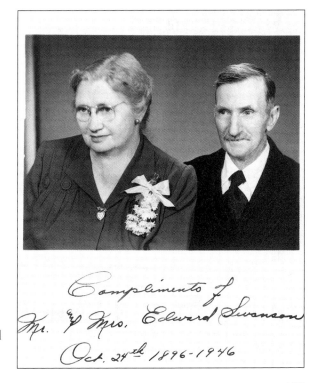

Richard Miller smiles with his cousin just in front of the Joshel coal silos, c. 1940. Many ethnic groups have contributed to this wonderful city. In the 1890s, there was a German Club being organized, a Scottish picnic being planned, an Irish evening of song and dance, and the opening of a Chinese laundry! Mayer A. Joshel opened his coal and feed business in the 1890s. He was elected Mayor in 1913. Mayer had fled Russia in 1886, when Jewish emigration reached record numbers due to discrimination and poverty. Three other Joshel brothers were also businessmen in Geneva. (Courtesy of Richard Miller.)

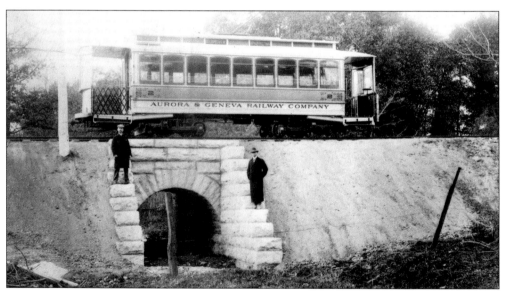

The Aurora and Geneva Railway opened interurban service from Aurora to Batavia in October of 1896, extended that service to Geneva in June 1900, and became part of the Elgin, Aurora, and Southern in 1901. This photo was taken around 1897 at a point north of Aurora, Illinois. Car #2—one of the line's first— was built by J.G. Bill Co. of Philadelphia. The first railroad in Illinois began operations in 1836, the same year that Geneva became the county seat. In 1853, the railroad from Chicago reached Geneva. It was first known as the Dixon Air Line and later, the Galena Division of the Chicago and Northwestern Railroad. (Courtesy of the Aurora Historical Society.)

The Joshel coal silos are standing tall in this scene taken from Garden Club Park in the autumn of 1988. By May, 1995, the 60-foot high silos, which date back to 1917, were taken down. High winds the previous month had caused the wooden structure on top of the silos to blow apart and the wood was falling on the street below. At their height, silos could each hold up to 600 tons of coal. (Courtesy of Richard Miller.)

Choose a delightful rendezvous at the Herrington Inn at the Fox River's Edge. The four-star dining room is named for the Shakespearian actor John B. Atwater who had settled in Geneva in 1870. On March 30, 1874 a butter and cheese dairy and creamery was built. Milk was kept cold in the river's rushing waters. The Geneva Rock Springs Creamery location is now home to the elegant and beautiful Herrington Inn. It is, indeed, a "landmark in luxury." (Courtesy of the Herrington Inn.)

This is the last remaining piece of machinery from the industrial area along the river. This power wheel operated machinery at the Howell Company. Its power came from a cable that crossed over the Fox River to a water wheel that was located in the Bennett Mill raceway on the east side. This power wheel is now located in the courtyard of "Geneva on the Dam," and this photo was shot in 1989. (Courtesy of Richard Miller.)

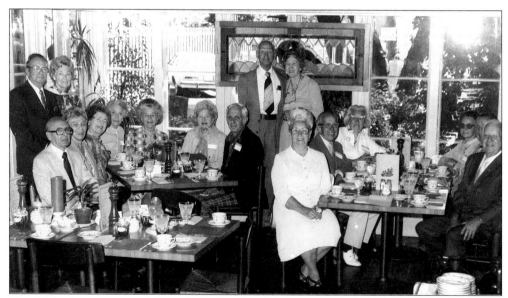

The 55th class reunion of Geneva High School's class of 1923, was held at The Mill Race Inn on September 23, 1978. Richard Miller is seated at the right table, left side of the table, between Evelyn Zweig and Mabel Fairbank. In 1923, a hit song was "St. Louis Blues," and in 1978, they may have thought they, indeed, could sing to the hit "We Are the Champions." (Courtesy of Richard Miller.)

Eight

THE QUIET BEAUTY OF GENEVA'S HIGH CHRISTMAS SEASON

And they traveled by night and they slept by day. For their guide was a beautiful, wonderful star.
—Henry Wadsworth Longfellow

The High Christmas Season is welcomed in Geneva amid a marvelous scene of color and beauty. The Christmas Walk, sponsored by the Geneva Chamber of Commerce, features a weekend of strolling, carolers, Christmas cookies, cider, roasted chestnuts, a 19th century Neapolitan crèche nativity collection on display at the Geneva History Center, and Santa Claus.

A Christmas House Tour features lovely homes decorated by Geneva florists and interior designers. A Christmas Tea and Craft Sale at the First Congregational Church of Geneva as well as the annual Cookie Walk by the Unitarian Universalist Society offer holiday treats. For the shopper, there are the many quaint stores of historic Third Street.

The Gift Box, D. Grunwald Fine Jewelers, Cocoon, the Paper Merchant, Little Traveler, the Kris Kringle Haus, and several fine restaurants are decorated with kind attention to the season. Geneva's Mayor Kevin Burns lit the city's Christmas tree to welcome Saint Lucia in 2001. All enjoy local choirs and bands, a horse-drawn carriage, and a Community Candlelight and Carols Sing at St. Mark's Episcopal Church. The city is resplendent with lights and activities for all the family during the Christmas season.

The Reinecke Home was featured in the 2001 Christmas Walk in Geneva. It was built in 1855, and is a splendid symbol of Geneva's early mercantile status. Originally named the LeBaron-Turner House, it is registered with the Geneva History Center. William LeBaron, a graduate of Harvard Medical School, and his wife, Sarah, had joined the Unitarian Church of Geneva in 1845. William was one of Geneva's distinguished doctors of that time. A newly remodeled wraparound veranda, inlaid wood patterns, a sweeping staircase, bright French doors, leaded windows, and inset china cabinets all contribute to the elegance of this remarkable home. (Courtesy of Sherri Weitl/Geneva Chamber of Commerce.)

A unique urban style has been brought to the Wach's grand historic house. Double doors open to a foyer with a shining brass chandelier. Bold red walls contrast with the white trim of the nine-foot tall living room. At Christmastime, the Swedish home is full of delicious aromas. Cardamom coffee cake, gingersnaps, loaves of limpa (rye bread), boiled cod, caraway cheese, and rice pudding were some of the aromas that permeated the kitchens. Around the festive tables lit with candles, family gathered for a tranquil feast shared in gratitude. (Courtesy of Sherri Weitl/Geneva Chamber of Commerce.)

St. Lucia's Day is observed during the holiday season. Family members awake to the sight of a daughter of the house attired in a flowing white gown, wearing a wreath of greenery with lighted candles about her head. She serves coffee and saffron buns in bed as she sings the old Sicilian song, "Santa Lucia." The medieval Italian saint was said to have shown compassion for the Swedish people of Varmland, Sweden, during a famine by bringing them food and drink. (From the collection of Jo Fredell Higgins.)

Sarah Robinson is reading *Twas the Night before Christmas* during the holiday season of 1981. Sarah was then four years old. The beauty and awe of the season comes to all hearts alike as they recall that the Christ Child was born just before dawn. Descendants of the early Swedish immigrants in Geneva celebrate the Christmas month with festivities and holy traditions. (Courtesy of Esther Wessels.)

Esther Wessels smiles for the camera with baby Richard at six weeks of age. He was born on June 29, 1939. The family lived at 520 North First Street, Geneva. Henry Horner was then Governor of Illinois. Abraham Heschel wrote "Just to be is a blessing. Just to live is holy." With the birth of Richard, both sentiments were true. (Courtesy of Esther Wessels.)

Esther Roper Wessels and Richard Herbert Wessels sit for this beautiful portrait in 1940. The photo was etched on copper taken by Anthony Ostroff of Aurora. Four days after Christmas, Richard was 18 months old. "A happy family is but an earlier heaven." (Courtesy of Esther Wessels.)

Dr. and Mrs. Wessels made their home at 860 North Bennett Street, Geneva. This is an old photo of their home. Cicero asked "Where could one settle more pleasantly than in one's home?" It seems that many happy occasions were celebrated in this stately brick home. Dr. Wessels died at the age of 92 on April 18, 1999. (Courtesy of Esther Wessels.)

Dr. H.P. Wessels and son Richard have taken a moment from their fishing to pose for the camera. The family coat of arms is Germanic and means "one who came from or lived near Wesel in Germany." The name is distinguished and prominent as shown in Burke's General Armory heraldic archival book. (Courtesy of Esther Wessels.)

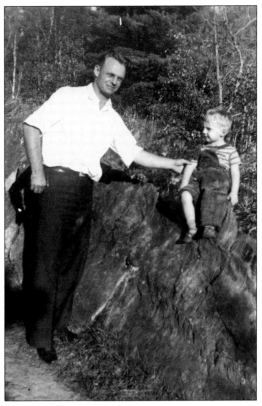

The Geneva Republican in December 1932 wrote that "with the big municipal Christmas tree ablaze with colorful lights, the entire business district with red and green streamers, the shop fronts filled with Christmas trees and the ground covered with several inches of snow, this special holiday season…is filled with fine and attractive, yes, desirable, things for the Christmas shoppers." In 1932, the renowned Radio City Music Hall opened in New York City. (Collection of Jo Fredell Higgins.)

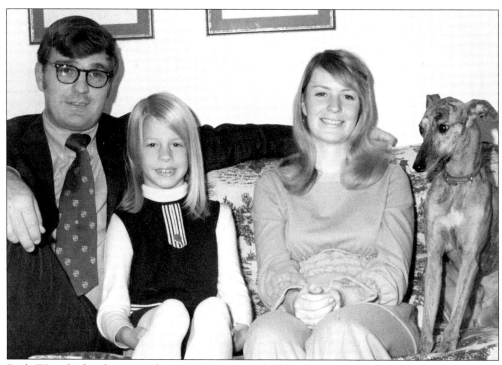

Dick Wessel's family pauses for a moment around Christmas in 1971, to smile for the camera. Dick, daughter Jennifer, Wendy, and Tiger, the whippet dog, are waiting to open their Christmas presents! (Courtesy of Dick Wessels.)

(Courtesy of Margaret Hutton.)

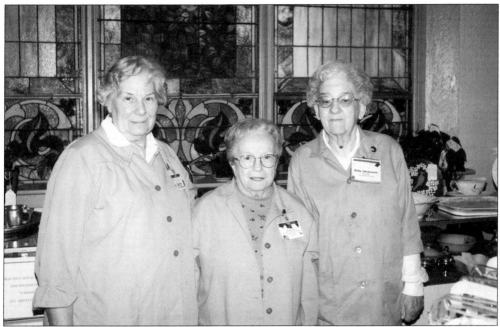

The former Swedish Methodist Church that was built in 1906 is now The Hi Hat House resale shop opened by the Delnor Community Hospital Auxiliary in 1998. All proceeds contribute to the needs of the hospital community. There are about 85 volunteers for the shop and one mentioned to me that Geneva is "an amazing place to be." Pictured here from left to right are the following: Betty Jakubowski, Alice Ahasic, and Dorothy Rocho, who are standing in front of the exquisite stained glass windows in the shop. (Photograph by Jo Fredell Higgins.)

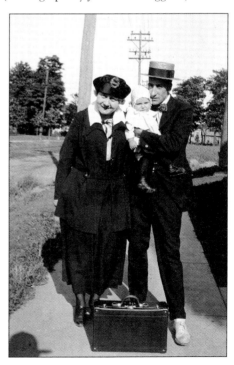

Merritt A. King, his au pair, and his papa in a straw hat stop for a moment in 1918. Merritt was about eight months old. (Courtesy of Merritt A. King.)

Merritt A. King shares his Christmas greetings from President and Mrs. George W. Bush at Christmastime, 2001. (Courtesy of Merritt A. King.)

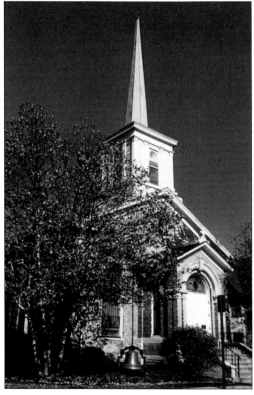

The First Congregational Church, United Church of Christ, is located at Hamilton and Fourth Streets. The land for the church had been bought by Gurdon I. Hollister for $55 on January 14, 1854. From 1847–49 crops had been bad and money scarce. To help support the new church, "slips" were sold. A slip was the name for a pew in those days. It cost $100 and the owner was subject to further assessment by the trustees. By 1869, the practice was discontinued. The cornerstone was laid in June, 1855, in the spirit and the faith of Nehemiah when he was rebuilding the wall around Jerusalem.(Courtesy of Dick Wessels.)

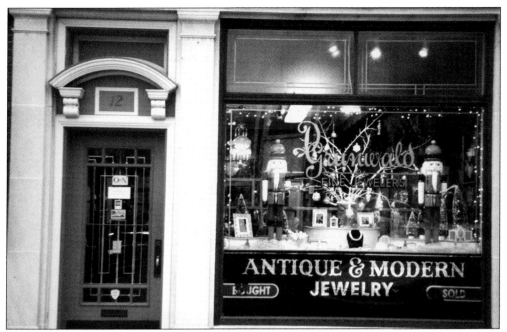

What a captivating window! Established in 1972 by Daniel and Martha Grunwald, this jewelry store on Third Street offers international as well as domestic and antique pieces. From England, France, Germany, Portugal, Italy, and Spain come hand-selected art objects, fine paperweights, Irish cut glass with small antique patterns, German Christmas ornaments, and many other precious and elegant items of beauty. (Photograph by Jo Fredell Higgins.)

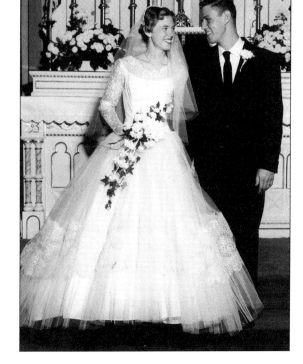

In December, 1962, Larry Moore and his bride, Julie Moore, were married at St. Peter's Church in Geneva. The song "Love Letters" was a hit that year. We can imagine that they had exchanged their own love letters prior to the nuptials. Tied with blue satin ribbon, the well-read letters remain a treasure 40 years later. (Courtesy of Lorraine Erdmenger.)

"Peace on Earth" proclaims this delightful holiday greeting from Barb and Ralph Bargman and baby, Michael. It is 1982. What an enchanting face! (Courtesy of Lorraine Erdmenger.)

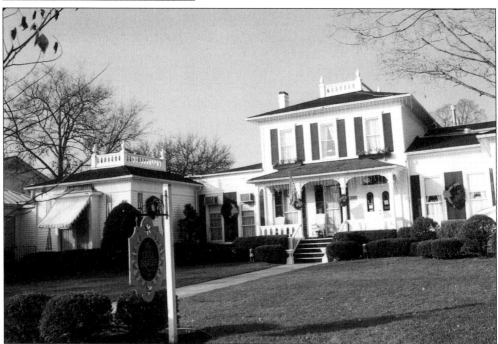

The Little Traveler was built by banker A.B. Moore in 1862, in an Italianate Victorian style. This shop presents an atmosphere of opulent informality. Each room offers a blending of goods that are both distinctive and pleasing. Sumptuous dishes, furniture, men's and women's clothing, soaps, towels, accessories, candies, and a tea room can be enjoyed here. The discerning shopper discovers treasures in each room. (Photograph by Jo Fredell Higgins.)

November, December 2001.
(Courtesy of Jo Fredell Higgins.)

I have three candles in my room,
Slender and long and white;
Their tips are buds of fire bloom
That blossom every night.

And one I light for memory,
All steady as a star;
And one burns clear for days to be;
And one for days that are.

I have three candles in my room,
Slender and tall and fair;
And every one a fire bloom,
And every one a prayer.

ARTHUR KETCHUM

An angel prayer card *c.* 1950.
(Collection of Jo Fredell Higgins.)

117

Dr. Steven Parker, D.N. is a naprapath who is licensed by the Illinois Department of Professional Regulation. His practice in Geneva offers connective tissue manipulation and requires knowledge of body mechanics and kinesiology. The approach demands a sensitive touch to evaluate injuries of connective tissue like muscles, ligaments, and tendons. Oakley Smith discovered this approach to healing in 1907, and said that "the body wants to heal itself." Dr. Parker grew up in Birmingham, Alabama. He started as a wide receiver on the Samford's NCAA division II national champions in 1971. (Photograph by Jo Fredell Higgins.)

Leigh Hamilton, age eight, is a third-grade student at Western Avenue School in Geneva. While waiting for her mom in Dr. Steven Parker's office, Leigh was reading a "Little House on the Prairie" book. The origin of the word naprapathy is from the Czechoslovakian word napravit (to correct) and the Greek word pathos (suffering). (Photograph by Jo Fredell Higgins.)

Nine

A Society That is Distinctive & Remarkable

Geneva reminds me of a New England village…there are many
here of excellent stamp, seeking to win from life its true values.
—Margaret Fuller, June, 1843

In *A History of Fashion*, we read that society likes the familiar needle and thread, the woven bodice, ancient fur, cotton and wool, linen or silk. Fashion can be influenced by political events, films, personalities, social, and sporting events. "Clothes make the man," according to the 19th century German writer, Gottfried Keller. One of the first recorded fashion shows occurred in Paris in 1858. Photographs appeared in the Parisian fashion journal *La Mode Prateque* in 1891. The photographs were tinted by hand using a two-color process. *Harper's Bazaar* began publishing on November 2, 1867, with 16 pages of a "repository of fashion pleasure and instruction."

In Geneva, dry goods and groceries, tailoring, and barbering shops were quite successful. Erday Clothiers opened their store on May 1, 1925. The emphasis was on custom tailoring and alterations. In 1929, the Merra-Lee shop opened. Sol Simon and Mrs. Rose Kozberg Becker were the partners. Several Swedish merchant tailors were John and Charles Albertson, as well as Francis Seastrom. Francis was in business from 1907 to 1925, and had studied custom tailoring in London.

In 1855, Miss M.A. Britt was selling bonnets to the ladies. In the 1850s, bonnets were small and worn off the back of the head. Brims were narrow and were tied under the chin with a big bow. The 1860 census listed only one milliner in Geneva. She was 18-year-old Clementine Stevenson from New York. With the change in hair fashions in the 1860s, bonnets had to be tilted over the forehead, as the hair then was pulled back in a chignon. (Collection of Jo Fredell Higgins.)

When Kate Raferty opened The Little Traveler in the early 1920s, her vision set the standard for all the interesting and vital shops of Geneva that were to follow. Third Street's unique residential shopping district still prospers today. Everything about shopping that makes it such a pleasure is here. Wrought iron benches, flowers in profusion, friendly salespeople, colorful and historic doorways that lead to the best in fine merchandise, all form the attractive picture. (Collection of Jo Fredell Higgins.)

THE LITTLE TRAVELER
MENU FOR NOVEMBER 2001

Thursday	1	Breast of Chicken Oriental
Friday	2	Zucchini and Tomato Quiche
Saturday	3	Hand Carved Turkey Breast
Monday	5	Mushroom Quiche
Tuesday	6	California Breast of Chicken
Wednesday	7	Hand Carved Round of Beef
Thursday	8	Turkey a la King on Patty Shell
Friday	9	Seafood Crepes with Spinach
Saturday	10	Hand Carved Roast Pork
Monday	12	Breast of Chicken Fedora
Tuesday	13	Veal Yeager
Wednesday	14	Hand Carved Ham
Thursday	15	Baked Cabbage Roll
Friday	16	Breast of Chicken Fadito
Saturday	17	No Luncheon
Monday	19	Turkey Tetrazzini
Tuesday	20	Breast of Chicken Romano
Wednesday	21	Hand Carved Round of Beef
Thursday	22	CLOSED
Friday	23	No Luncheon
Saturday	24	No Luncheon
Monday	26	Breast of Chicken Piperade
Tuesday	27	Creole Style Pork Chop
Wednesday	28	Hand Carved Turkey Breast
Thursday	29	Breast of Chicken with Sherry Cream
Friday	30	Asparagus Quiche

(with accompanying varieties of vegetables,
salad, rolls, dessert and beverage)

232-4200

Prudence Hartwig, a seamstress, was put in charge of the first Little Traveler tea and sale. With all the excitement, Prudence forgot to list what she sold and how much she collected! More tea sales followed and in 1922, Mrs. Kate Raftery turned her home into a shop and The Little Traveler was born. Buying trips to the Continent and to England brought back such beautiful items as Italian antiques, silver, silk, and leather. From China arrived silk brocades, ceramics, and kimono-style coats with bright silk linings. (Collection of Jo Fredell Higgins.)

The 1938 band concert competition was held at the University of Illinois. From the Geneva High School band, pictured here from left to right, are the following: Burton Wood, Lorraine Smith, Laurel Peck, Tom Peck, Francis Jarvis, and James Galley. Popular songs of that era included "Summertime," "Thanks for the Memory," and "When the Saints Go Marching In." (Courtesy of Tom Peck.)

Snow crystals were first sketched in an 1855 book titled *Cloud Crystals*. In 1931, Wilson Bentley published an atlas of crystals he had photographed through a microscope. Depending on temperature, humidity, and wind, snow crystals can resemble stars, columns, plates, needles, capped columns, asymmetricals, or other combinations. This scene shows Jefferson Street following an ice storm. The squirrel atop the ladder is unaware that his photo will later appear in a book! (Courtesy of Janet M. Dellaria.)

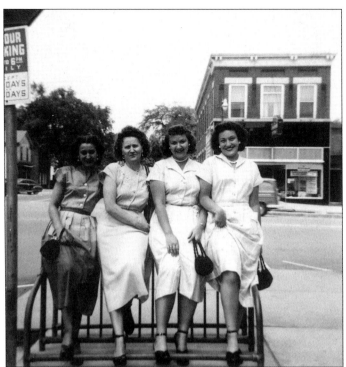

In the summer of 1950, Sophie Xagas captured these four Geneva ladies in a charming pose. Pictured here from left to right, Joan Hanus, Hattie Gruenler, Gladys Slovak, and Eleanor Hanus are getting ready to have their lunch at The Little Traveler. (Courtesy of Joan D. Obermayer.)

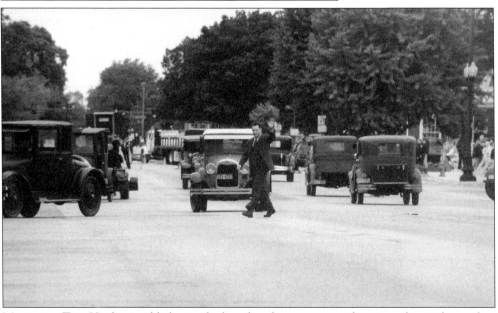

Movie star Tom Hanks stumbled out of a boarding house room and met gunfire in front of an Associated Radio Store in downtown Geneva. "The Road to Perdition" was filmed in Geneva in May, 2001. This DreamWorks Pictures movie was set in the 1930s, so a Depression-era Main Street was created by Dream Works' carpenters and painters. A contract with the city required that Geneva be mentioned in the credits, and that the Geneva Hotel and the Geneva Theater must be called such in the film. Steven Andrzejewski of DreamWorks said that "One of the reasons we chose Geneva was for the integrity of the architecture."(Courtesy of Carol Leonard.)

An extra is pictured here posing by a 1930s era car as filming for the movie "The Road to Perdition" begins. Irish gangster John Looney is played by Paul Newman. Tom Hanks plays his hitman Michael O'Sullivan. Michael takes his only surviving son down a road of revenge and self-discovery after his wife and other son are murdered. "Perdition" is an archaic term for "utter destruction or hell." The movie's release date is set for November 2, 2002. (Courtesy of Carol Leonard.)

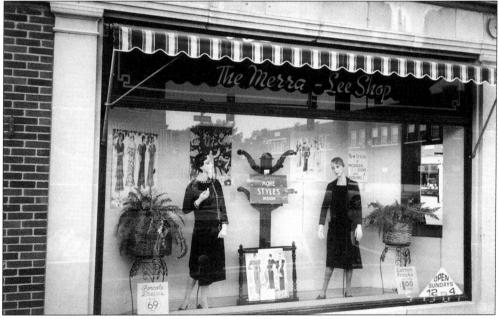

Since the Merra-Lee shop actually opened in 1929, this window display is quite appropriate for the filming of "The Road to Perdition." The shop features quality clothing, distinctive shoes, accessories, special occasion dresses, lingerie, hosiery, and jewelry. Chanel Chadock, an employee of DreamWorks, was quoted as saying that Geneva is "a picture postcard. It is absolutely stunning."(Courtesy of Margaret Hutton.)

On May 10, 1905, President Theodore Roosevelt's train stopped at the Geneva depot and Roosevelt addressed the large crowd from the rear platform. President Kennedy visited in 1962. President Ronald Reagan was in Geneva on April 16, 1982, using St. Peter's School as a setting to promote his proposal to allow tax credits for parents of students in private schools. St. Peter's was chosen, in part, because the land surrounding St. Peter's could accommodate the President's entourage of four giant helicopters. (Courtesy of Richard Miller.)

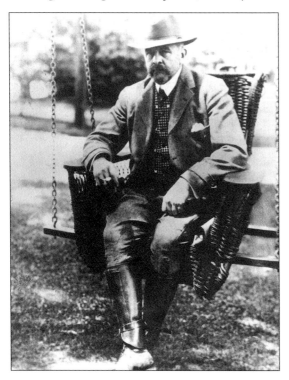

Colonel Fabyan, pictured here, received the honorary title of "Colonel" from Governor Richard Yates on behalf of his efforts in military research. Prominent scientists lived and worked at Riverbank Laboratories. Their groundbreaking work led to the invention of sound-absorbing plaster, the birth of the field of cryptology, and advances in military intelligence. Riverbank is considered by many to be a direct lineal ancestor of the National Security Agency. George Fabyan died at Riverbank Villa, Geneva, on May 17, 1936, at the age of 69. He is buried in Foresthill Cemetery in Boston. (Courtesy of Friends of Fabyan.)

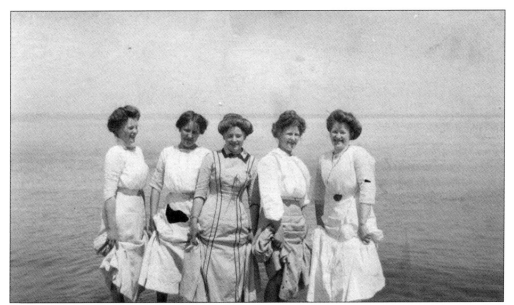

These women are enjoying their weekend excursion to Chicago and frolic by Lake Michigan. Their names are unknown. Could we imagine that they were graduates of Geneva High School, were married with children, and took this Saturday to picnic by the Lake together? That June day was sunny and warm, just right for a summer's sojourn. (Courtesy of Geneva History Center.)

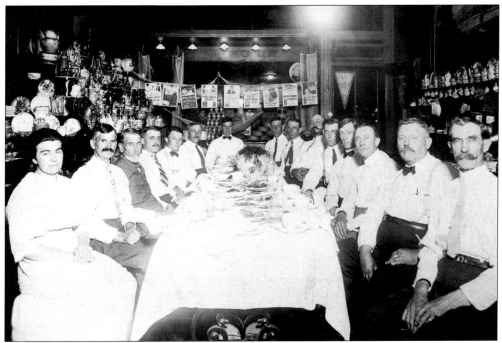

Frank Jarvis is the fourth from the left in this photo of salesmen of the Grand Union Tea Company. Frank was the sole owner of the Wrate block, Wrate house, and the Wrate subdivision following his mother's death. He used the basement level of the house as a warehouse for his tea company. (Courtesy of Geneva History Center.)

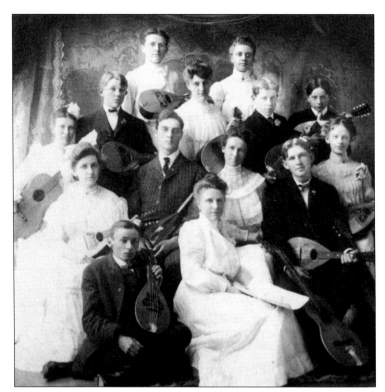

This photo was taken around 1902–1904 and shows the Mandolin Class. Miss Westrand was the teacher who is sitting in the front with the sheet music in her hand. The origin of the word for this musical instrument is Italian. Found in cave paintings in France in 8500 B.C. were depictions of one string, lute-like instruments. Mandolin playing was in vogue in the 1850s in America as an amusement for the growing leisure middle class. (Courtesy of Geneva History Center.)

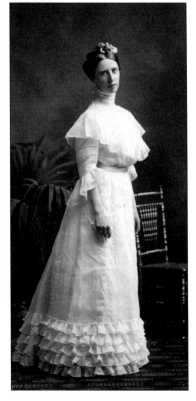

This exquisite dress was worn by Kate Hawkins at her graduation at the turn of the 20th century. Miss Katie Lu Hawkins was born February 16, 1882, in Geneva. Her parents were Henry and Kate Hawkins. Her sisters were Mabel Hawkins and Alice Hawkins Willimin. In the late 1930s, Fireside Book Chats were popular events. From these, a "Friends of the Library" group was organized in 1939. When she retired from the Geneva Public Library on April 1, 1956, Katie had been head librarian for 40 years. (Courtesy of Geneva History Center.)

BIBLIOGRAPHY

Ackerman, Diane. "Let It Snow!," *Parade* magazine, December 16, 2001.

American Legion Magazine. November 2001, Volume 151, No. 5.

Balfour, Clara A. *Garden Lovers Quotations*. Great Britain, 1992.

Cooper, Claire M. Sesquicentennial Book Committee, Editor and Historical Chairperson. *Tremont, Illinois 1835–1985*. 1985.

Daily Herald. Section 1, Paddock Publications, Inc. January 5, 2002.

Dunham-Hunt Historical Preservation Society republication. *1871 Atlas and History of Kane County Illinois*.

Ehresmann, Julia M., editor and Dietrich, Edward,photographer. *Geneva, Illinois: A History of its Times and Places*. Geneva, Illinois, 1977.

Garrison, Webb. *Why You Say It*. New York, 1992.

"Geneva's Christmas Walk Set to Begin Friday." *Beacon News*, pg. A4, December 3, 2001.

Geneva Historical Society 50th Anniversary, 1943-1993.

Geneva Republican, September 23, 1914 and November 15, 2001.

Hanson, Earl, Ph.D. *A Place for Midsummer. The Scandinavian Tradition of Good Templar Park*. Geneva, Illinois. 1975.

Harris, Christie and Johnston, Moira. *Leafing through History: The Dynamics of Dress*.

Hiebert, Laura and Larson, Darlene. *The Fabyan Legacy*. Geneva, Illinois, 1992.

Kane County Chronicle. Profiles 2000, pages 15 and 44. March 21, 2000.

———. "A Picture Postcard" March 8, 2001.

Kane County History pamphlet. Lorraine P. Sava, county clerk.

Keating, Gerard and Janet. Compiled by current owners of 316 Elizabeth Place. *The History of Henry Bond Fargo and Family*. 2000-2001.

Kelly, Jack. *Queen Flea: The Helen Robinson Story*. St. Charles, 1997.

King, A.I.R., W.R. *The Bronze Plaques of Geneva. A Sketchbook by the Women's Auxiliary Community Hospital*. Geneva, Illinois, 1975.

LeBaron, William. *Kane County Past and Present*. 1878.

Midsummer News. Swedish Day. Good Templar Park, Geneva, Illinois. June 18, 1972 and June 16, 1991.

Origin and Evolution of Illinois Counties. George H. Ryan, Secretary of State, January 1991. Reprinted by the authority of the State of Illinois.

Our Idea of a Ballgame. Kane County Cougars promotional material.

Sesquicentennial Commemorative Calendar. Geneva, Illinois, 1985.

"Sheep Barn of S. Peck, Geneva." *Geneva Republican*. February 27, 1915.

Stratton, Joanna L. *Pioneer Women*. New York, 1981.

The Sunday Post Magazine. November, 1997.

"Winter Chautauqua offers outdoor, indoor fun" *Beacon News*, pg. A4. February 13, 2002.

Weblinks:

www.oscarswan.com

www.geneva.il.us

www.genevaparks.org

www.genevachamber.com

www.geneva.lib.il.us

www.mayorburnsgeneva.il.us

About the Author

JO FREDELL HIGGINS is an internationally published writer and award-winning essayist and poet. She holds an M.S. in Education and has taught pre-schoolers to 90-year olds during her teaching career. Her photographs have won numerous awards. One was selected to be included in the *One Day USA* book published by the U.S. Conference of Mayors. Jo is currently Volunteer Coordinator for the Adult Literacy Project at Waubonsee Community College in Aurora, Illinois. She has presented at local, state, and national literacy conferences. Her volunteers have won local, state, and national awards. Jo serves as chair of the GAR Commission, vice-chair of the Aurora Township Youth Commission, President of the Board of Directors for the Townes of Oakhurst, and on the Aurora Township Foundation board. Her photo exhibits have been shown at the Aurora Public Library, as well as First Night Aurora celebrations. Jo's articles have been published in *The Instructor, Teacher, Today's Catholic Teacher, Illinois* magazine, *ChildCare* magazine, Dublin, Ireland's *Reality* magazine, as well as 40 other publications. Her poetry has been published in *Her Echo*, a women's poetry anthology, *New Voices in American Poetry 1975*, the Indiana Fine Arts Society's *The Poet*, Morton Arboretum's *White Words of Winter* anthology, *A Different Drummer, New Jersey, 1977*, and *Poems of the World* anthology in 1998, 1999, and 2000. Jo was the official photographer for Literacy Volunteers of America-Illinois conference in 2002. She volunteers with the Fox Valley Hospice, the Morton Arboretum, and the Salvation Army. Arcadia Publishing published her first book, *Naperville, Illinois*, in 2001. Jo was a statewide judge for Illinois Governor's Home Town Award in 2002. She enjoys gardening, swimming, traveling, bicycling, and card games. Her daughter Suzanne and grandson Sean live in Madison, Wisconsin.